The Art of Abstract Painting

A Guide to Creativity and Free Expression

Rolina van Vliet

SEARCH PRESS

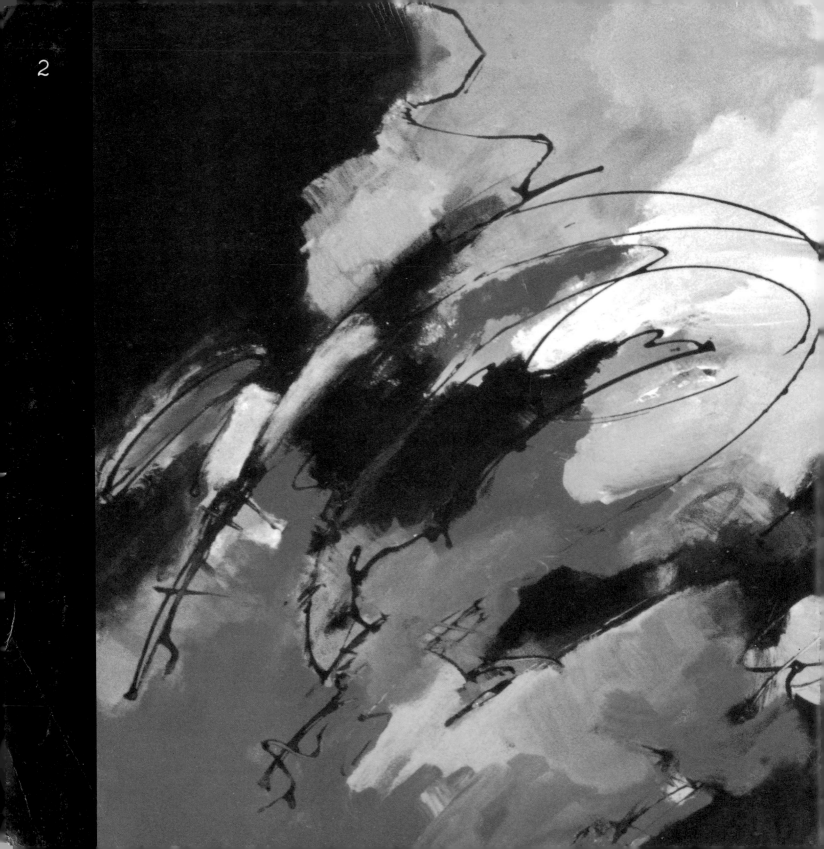

■ Acrylic on canvas 100 × 120cm (39¼ × 47¼in)

A painting is the most personal reflection of your being, your emotions and your character. At some stage in our career as painters we arrive at this point, but a great deal goes before it. We all begin by learning the techniques and rules of painting, in order to use them to convey reality as 'genuinely' as possible on a flat surface. Sooner or later comes the moment when we tire of this, and we begin our search. We decide to leave all the rules of painting behind and discover that there is an entirely different world of painting: that of abstraction. We realise what real freedom is and lay the foundations for expressive painting: free, unrestrained, spontaneous. It then becomes evident that we have absolutely no need of that outside world and reality in order to express ourselves, and that reality was in fact actually a restraint on us. The moment I was able to let go of reality was to me a liberation. At the same time, I realised that I had arrived at the point at which my work was fully my own, arising from my inner self. I can say of each painting that arises in this way that it is a direct reflection of my being, my emotions and my personality. It gives me a good feeling knowing that this is unique, this is individual, this is what I am.

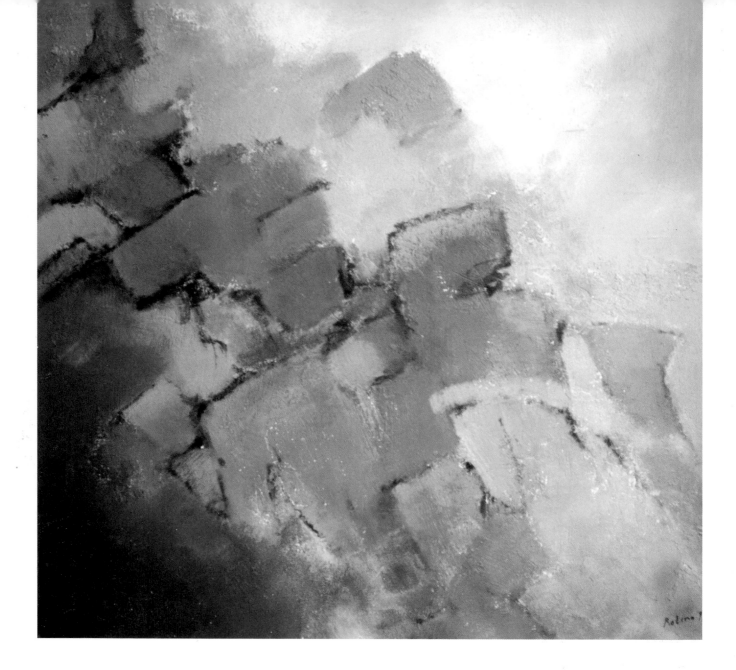

■ Acrylic on board 100 × 100cm (39¼ × 39¼in)

An abstract painting is essentially a non-representational painting. In other words, the shapes we see are not recognisable to us. They cannot be named, as they can in a figurative painting, where we can see a landscape, a flower, a house, etc. Such paintings are possibly even named after the objects in them, but an abstract painting is, in fact, nameless, and so you will have to think of a possible title yourself on the basis of the background and the idea from which it originated. However, a title is not intended as a substitute for conveying your intentions. You must make sure you express these through your work. It is not even absolutely necessary to give an abstract painting a title. After all, if it is good, the work will speak for itself.

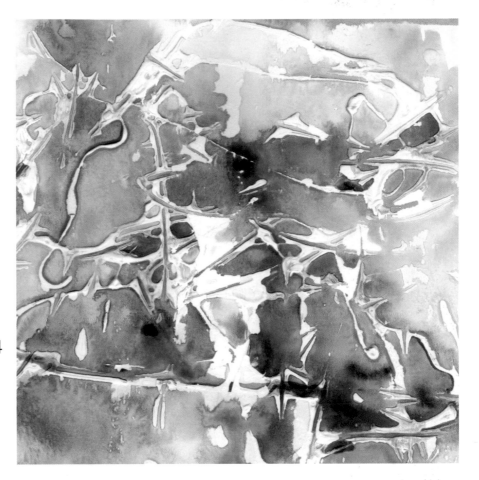

■ **Detail of a textural study**
When we paint abstractly we can animate our work with texture. This is an experiment in which white latex was first sprayed on to the paper. Then scratches were made in it. When it was dry I applied colour with watercolour paint, revealing the effect of the texture of the latex.

1. Introduction

Welcome to the world of free expression

You like painting and are keen on expressive colours, but you are stuck and would like to paint differently, more informally and more freely. So you are looking for an alternative, a new challenge, modern and invigorating. You are faced with the choice of continuing in the same old way or following a completely different road, that of freedom, creativity and expressiveness.

I was once at that point myself, and firmly decided to leave everything behind me and choose a different route. This road was not mapped out for me, and I had only a vague idea of my final destination, until I discovered the abstract school and straightaway knew: this is it. For the first time, my artistic abilities were being given the scope they really needed. This was how I discovered the essence of painting: free, unrestrained, making and creating from within yourself. The road to achieving this is sometimes a long one, but I can wholeheartedly recommend it to you.

So, take that step. Be daring and discover the boundless possibilities of that other world of painting… go abstract.

To help you with this, from my experience as a teacher and a fine artist, I have developed an alternative method of painting for you: a discipline that familiarises you with abstract painting in an easy to understand way; a method that will point the way to your own talent and that will make true creativity, expressiveness, originality and individuality accessible to you.

Let us set out together and begin on the great adventure that lies before you.

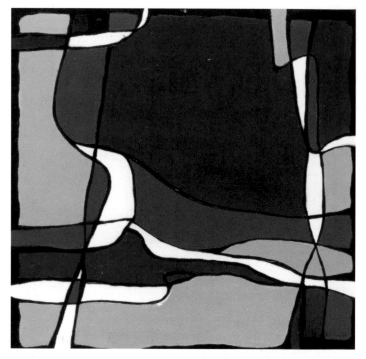

■ Acrylic on MDF 40 × 40cm (15¾ × 15¾in)
Medium-density fibreboard (MDF) panels and acrylic paint go very well together. Make sure you have a good ground for your painting by sanding the panel and treating it with gesso. Acrylic paint is very colourful and can be used either undiluted or mixed. Here the paint has been used unmixed. The primary colours red, yellow and blue, together with black and white, give a strong contrast. The composition has been carefully constructed with the emphasis on balance, harmony and unity in shape and colour. The different colour planes have been given extra emphasis by black contour lines.

Be daring...!
...Go abstract,
and a whole world opens up before you

Take that step and open yourself up to a way of painting where everything is allowed and nothing is compulsory.

Give yourself that freedom and throw the straightjacket of all the rules overboard.

Re-learn how to use your feelings, imagination and spontaneity.

Discover that there is infinitely more than painting from reality.

See how your self-confidence grows as you learn to accept and appreciate your own input.

Enjoy the process of creation, in which nothing ever has to be 'wrong'.

Experience the pure joy of playing with material, colour, shape, ideas and design.

Realise that you are capable of producing something unique on your own and...

experience the essence of free expression.

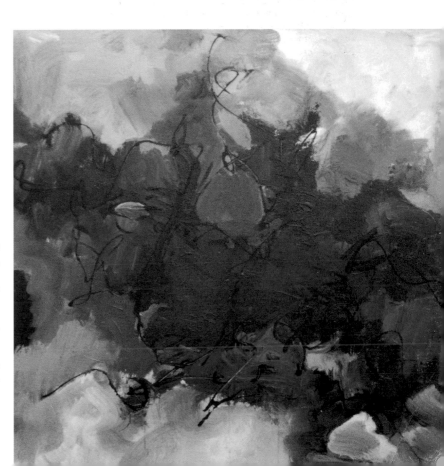

■ **Acrylic on canvas 80 × 80cm (31½ × 31½in)**
This work shows that there are many ways of using acrylic paint. If we compare it with the last figure, this work is in many respects the opposite. The paint has been applied far more expressively and spontaneously. The same colours – red, yellow, blue, black and white – have been used here. By mixing the paint directly on the canvas, new colours have been created. The shapes here are not rigid and delineated, but put on freely and roughly. Here, too, black lines have been used, not to outline the colour planes, but to add dynamic, spontaneous and playful emphasis.
Both works are completely abstract. They do not refer to nor do they originate from any kind of reality. However, they differ vastly in style and character.

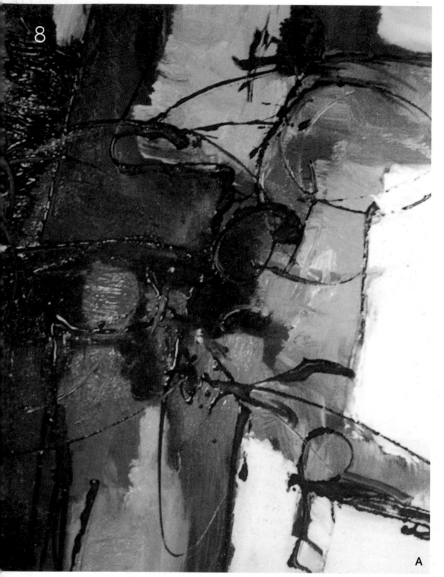

A

So, you've gone for abstract

It sounds exciting and challenging, but what is abstract?
What do I paint, then, and how?
What do I begin with?
How do I know what to do?

In this book, I hope to be able to answer all your questions and to accompany you on your voyage of discovery.

What this book has to offer

- The text gives you information about the background, goal and procedure of the abstract method, in which the development of your own talents is the main focus.
- The illustrations clarify the content of the method. The text next to them (indicated by a square) gives you extra details about practical matters, such as technique, composition, construction of the work, materials and pictorial language.
- The study exercises and tips are intended to give impetus to your creativity, the emphasis being on play as the ideal teacher.

Theory to...	motivate
Illustrations to...	inspire
Study tips to...	activate

and... enjoy!

Rolina van Vliet

■ **Acrylic on canvas 80 × 100cm (31½in × 39¼in)**
Six illustrations of a painting in the making. Figure A is a detail from the end result. Figures B to F show the way and the sequence in which the work was constructed. We can begin a painting by making a sketch (B). This has the effect of dividing the plane and at the same time makes the composition clear. The bright, light colours were applied first, and then the black. Spontaneous mixes on the canvas have given rise to various surprising colour variations. Finally, a number of line accents were applied over the painting with black paint.

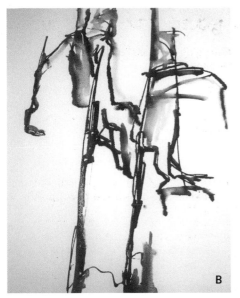

B

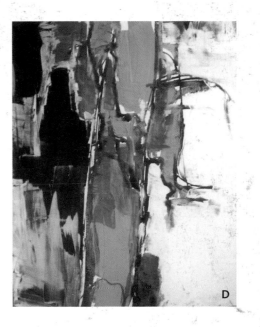

D

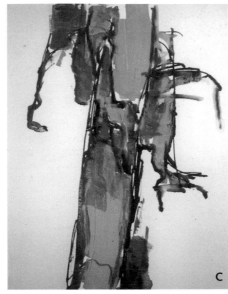

C

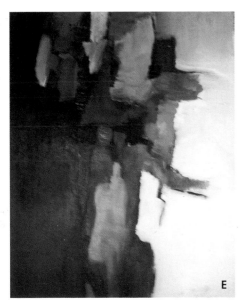

E

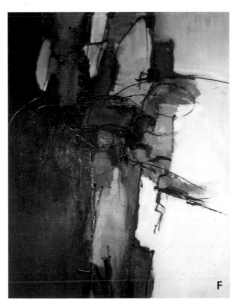

F

Study tip

- When studying, try not to spend too much time on detail, so always choose a large format. This will literally give your creativity more scope. Additionally, you will become acquainted with large painting gestures and develop more spontaneity and expressiveness.
- Let us start with the first assignment. Try the order of work of Figures B to F, deliberately choosing a <u>different way of plane division, different shapes, different colours and accents.</u>

This book deliberately does not contain step-by-step examples. A procedure of that kind is in complete contradiction to the essence of the abstract method, where your own efforts and own talent are the number one priority. You must avoid copying to any extent at all. The study assignment set here shows you how to deal with the illustrations in this book. They are there purely and simply to give impetus to your own artistic faculties – nothing more, nothing less.

2. The incentive

Painting is intended as a means of expressing ourselves on a flat surface. In practice, however, it is evident that true expression is produced only to a limited extent, which may be the reason why we often become grounded in superficiality and do not accomplish striking work with sufficient eloquence and atmosphere. So, if we all still go for painting, is there not a way to improve that lack of expressiveness and originality; a way of giving our work more depth and artistry?

These are questions with which I have often been confronted as a lecturer. Evaluation, analysis and more detailed research have led to the following conclusion. If our work does not actually produce the desired result, this is not so much to do with a lack of technical ability. On the contrary, it is mainly to do with a lack of personal input, vision, imagination, daring and the inability to develop our own solutions and ideas.

This prompted me to go in search of the cause of this deficiency, and in doing so I discovered the skills we need as painters.

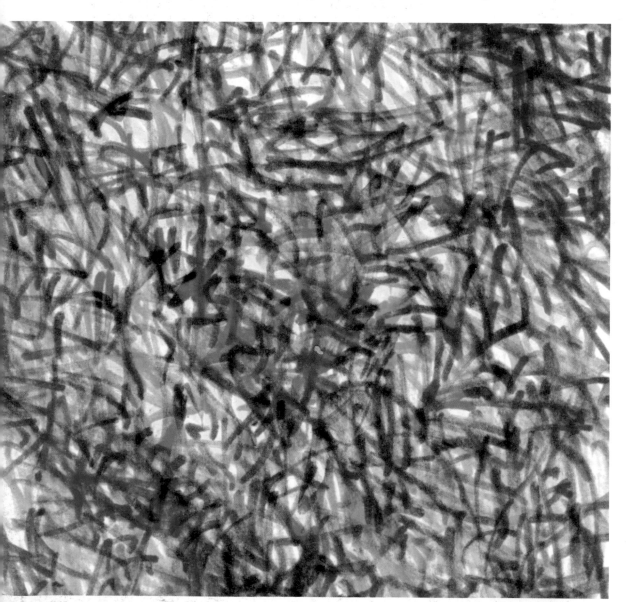

■ Playing with line and rhythm

A great deal of experience is needed to develop painting skills. The more we practise and experiment the broader is our basis.

Practice does not need to be particularly complicated. Here, a study has been made with felt-tip pen, with the emphasis on line, colour, rhythm, repetition and texture.

Study tip

- With a coloured pencil or felt-tip pen, make a number of variations on this theme. Try to make full-image compositions and structures, using the element 'line'. You could also try it with paint and brush. Vary the direction, length and thickness of your lines, making some straight, some curved, next to one another or jumbled up.

Painting skills

As with any artistic expression, painting also requires a number of specific skills, which give direction to the ultimate painting process. We can classify them roughly as follows.

– **Technical skill** This is knowledge and experience of materials and techniques. It is fairly specific and we usually begin our career as an artist with this primary basic skill. Books, magazines and classes give us plenty of information and opportunity for study.

– **Painterly skill** This is applying the rules of painting in order to portray reality on a flat surface. Knowledge and experience of things such as perspective, plasticity, shade, three-dimensionality, composition, colour theory and so on, all of which define a picture, help us to reproduce reality. These are rules with which we can achieve a three-dimensional reproduction on a two-dimensional surface.

– **Artistic skill** This involves the many emotional aspects that guide our act of painting. We know them as feeling for colour, feeling for composition, for shape and so on. The more we make use of this instinctive way of acting, the more strongly our internal artistic resources are developed. We can improve this artistic intuition first by consciously gathering knowledge, and then by dealing with it instinctively. Artistic skill is responsible for the artistic character of our work.

– **Skill of expression** This is the ability to give expression to your own ideas, feelings, involvement and the things that move you, in other words the mental and emotional content. Not an easy task, and attainable only if we are able to give and reflect ourselves completely. Painting is thus a pure means of expression, not with words or language, but in a pictorial language. True expression resulting from involvement and the power of emotion can thus lead to great depth, allowing us a glimpse of nature, character, heart and soul.

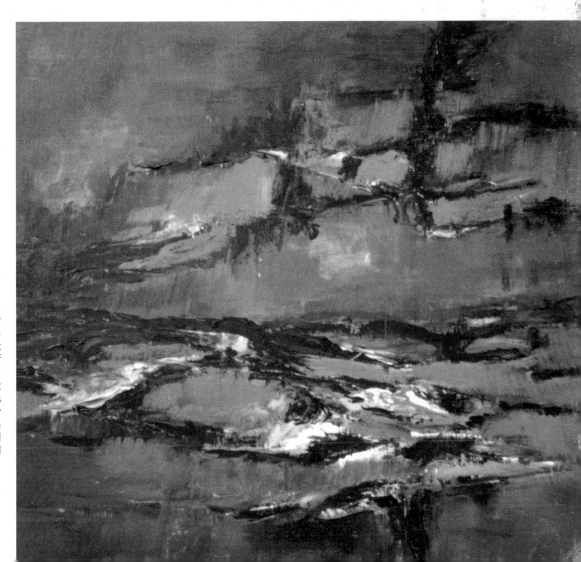

■ **Acrylic on board 80 × 80cm (31½ × 31½in)**
A painting in monochrome colours. By using different blues in combination with black, white and a tiny spot of green, it has become possible to apply plenty of variation and contrast in tone and colour. The work began with a transparent underpainting, over which striped accents were applied with a painter's knife. For this painting, I had the sea somewhere in mind, which is why I chose horizontal accents alternating with a few vertical ones to produce balance.

Starting with yourself

My research has revealed that, in general, technical and painting skills are frequently practised and taught, whereas artistic and expressive skills are rarely brought to our attention. I conclude that this is the cause of the frequent lack of eloquence and originality that can be observed. This was the reason why I developed a method of painting that makes it possible consciously to work on that deficiency. To achieve this, the emphasis must be on painting that comes from yourself, your inner artistic resources, because this is where the basis for creativity, expressiveness, originality and individuality resides. Therefore:

back to	the root
back to	the origin
back to	yourself, your inner being
	your gifts and talents
	the sources of your creative ability
	the artistic basis for every artist.

A pioneering method

The abstract method distances itself from teaching methods concerned only with developing technical skills and reflecting reality. Instead, the method aims to develop artistic skills and consciously chooses the abstract approach.

This method of painting emphatically moves away from the use of step-by-step examples, of which much use is generally made. This is a procedure that, although having some value, is, in essence, a considerable obstacle to the development of artistry and creativity. If you want more than technical perfection, you must first of all concentrate on developing your artistic skills. The study programme of the abstract method has been specially developed for this.

So, follow the abstract method,

and start with the source:

your latent talent.

■ **Acrylic on canvas 80 × 80cm (31½ × 31½in)**
This composition arose from a spontaneous dynamic play of lines. The open area at the top reminds us of sky and the line below of the horizon. The work is suggestive of a landscape, though that was not the origin. We can therefore work in a completely abstract way and yet afterwards see reality in it.

Study tip

• Make a composition based on a few spontaneous lines running predominantly vertically.
• Make a second composition in which diagonal lines dominate. Elaborate both in other colours.

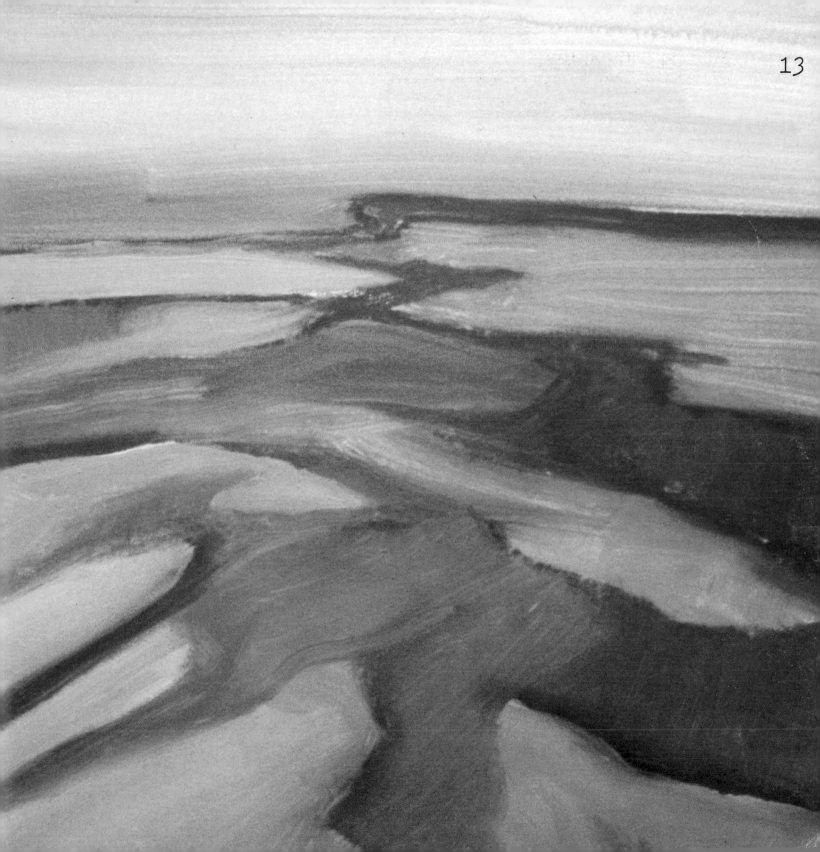

3. The goal

Every method of study focuses on a specific goal. The objective of the abstract method of painting is linked to the essence of painting as an artistic form of expression. In the abstract method, artistry is inextricably associated with creativity, expressiveness, originality and individuality. Consciously dealing with and working on these extremely important basic conditions is therefore vital to the abstract method. What do we understand by these terms?

Creativity = creative and original, making and/or designing something yourself; creating something yourself without any influence is new, unique and individual. Creativity works well only if there are no immediate solutions available. It requires total freedom of action and a sensitive, perceptive mind.

Expressiveness = your own artistic expression; expressing emotion in a striking and meaningful way and therefore giving a voice to the artist's vision. Thus expression exists only when feelings come into play. So, return to yourself, to the root. Shut yourself off from influences and instructions from outside, and look for a personal language of expression based on true involvement.

Originality = being original; emanating from someone personally, not imitated, bearing one's own hallmark, unusual and surprising. Originality is a very elastic concept that is sometimes used carelessly. In practice, quite a lot is still 'borrowed' from others. There is nothing wrong with this as study material, and for gathering experience. However, presenting such work as original is going too far. After all, if your work is not completely your own idea, it can hardly be called original. Particularly in the case of abstract work, I would like to make a plea for maximum originality, in which any relationship with work that is already in existence must be ruled out. Originality can be learned, and begins with honesty and a willingness to let go of all support from outside.

Individuality = characteristic feature, own nature; in other words, one's own signature. The more individual solutions are sought, the more an individual 'script' will emerge, distinguishing one's own work from that of others. Individuality reinforces originality and paves the way for an individual style, our personal pictorial language.

By making the essence of painting accessible, the abstract method hopes to improve the frequent problem of lack of character and artistry.

Those choosing painting as a means of expression must set themselves the task of striving towards creativity, expressiveness, originality and individuality in as pure a manner as possible.

■ **Acrylic on canvas 80 × 100cm (31½ × 39¼in)**
This painting has been constructed from free shapes in powerful, contrasting colours. Repeated colour accents create harmony and unity. Textural accents animate the colour fields and bring them into contact with one another. Smaller colour accents act, together with contrast, as the point of special interest in the composition.

16

4. **Principle and theory**

It is important to understand the principle that the method is based on. In order to be able to create artistic work, we need a number of skills. They guide our actions instinctively and intuitively. We know them as a feeling for colour, feeling for line, for shape, composition, unity, harmony, and so on. They are qualities that are associated with aptitude to some extent, but they can definitely also be developed. Ultimately, they will guide our painting process. How can we reach and subsequently activate and improve these artistic skills, our internal resources?

Activating our internal resources

A prerequisite for the proper use of our internal resources is the presence of a certain stimulus, a challenge, or a reason to activate them. Just as the cardiovascular system of an athlete is activated as soon as it is required and there is therefore a certain stimulus and incentive to start working extra hard, in the same way a painter's feeling for colour, shape, composition and so on is activated as soon as there is a stimulus, an incentive and a certain need for it. The more

we stimulate our internal resources, the stronger they can become. In other words, practice makes sense, just as training goes without saying for athletes.

The root of every stimulus is a problem that requires a solution, a challenge to which we must find the answer. So, we consult our internal resources, and at that moment our creativity is activated. We get inspiration and an individual new idea emerges.
When you paint using a model, this stimulus is missing. After all, you do not need to devise any solutions yourself and do not need to use your internal emotional resources. The model already tells you what sort of composition you need to use, what colour, shape, etc. Your creativity simply does not come into play and this could well be disastrous for the development of your talent.
So do not confine yourself to executing the ideas, assignments and models of others. Do not look for cut-and-dried solutions, because they stand in the way of your own creativity. Moreover, you also run the risk of becoming dependent on models and/or teachers. These helpful models become your downfall if you do not stop in time. You must realise that the real basis for artistic work is in yourself alone.

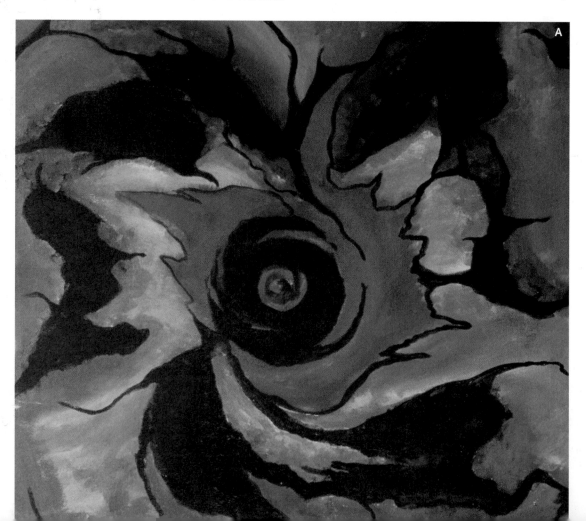

■ B Study in mixed technique

A useful way of discovering shapes is to make a 'scribble drawing'. The basis of this study in chalk and watercolour was a scribble drawing. The scribble reminded me of dancing figures and I therefore decided to use cheerful colours to complete it.

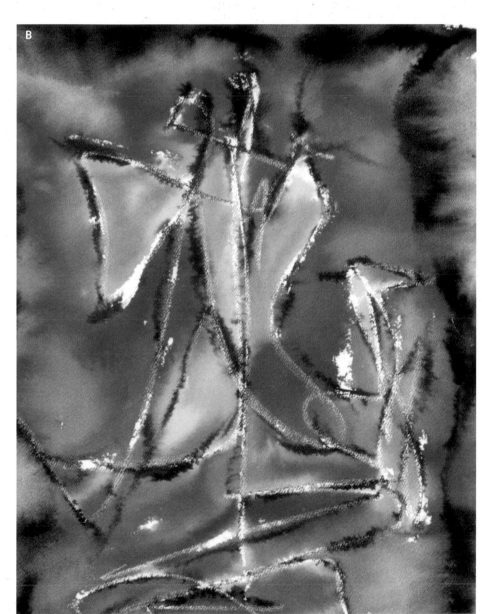

■ A Acrylic on board 80 × 80cm (31½ × 31½in)

We can work with many different colours, or else restrict ourselves to one particular family of colours. This work, in the warm colours red, yellow and orange, is given extra power by the contrasting effect of black. The fairly central round shape draws the eye very strongly towards the middle of the work. The black lines and planes give our eye the chance to leave that centre again and further explore the picture.

Study tip

• Design your own composition and then use strongly contrasting colours to elaborate it.
• Repeat the assignment with a weak contrasting colour.
• Make a study in black and white, with a lot of contrast in the centre and little round the edges.

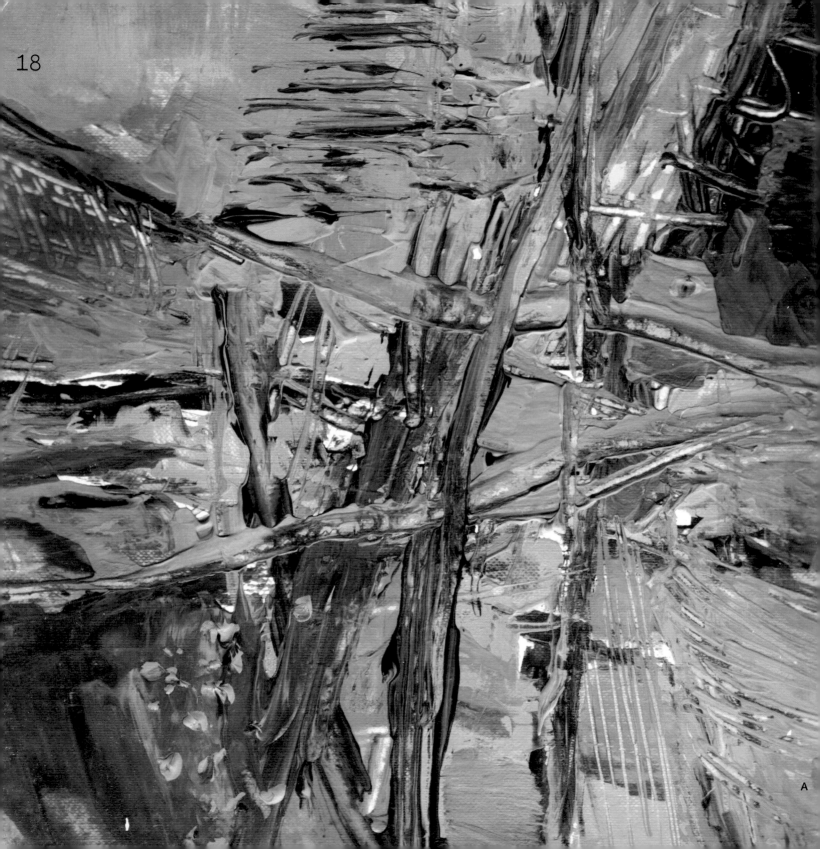

In search of freedom

Painting as an artistic expression has many bases, varying from enthusiasm and passion to an enjoyable leisure activity, amateur or professional, each according to his or her own level, idea, efforts and talent. Whereas one person is looking for relaxation and technical skill, another is looking more for the challenge of achieving representational art. Yet virtually everyone will sooner or later feel that drive towards more expressiveness, and abstract painting can help in this.

This often requires a readjustment. Experience has taught us that we are unconsciously fixed on the idea that we must produce a successful work. To achieve this, we meticulously follow the rules of painting, such as perspective, shade, depth, proportions and so on, to be as sure as possible of attaining the intended result. After all, it needs to look like something and, if at all possible, be hung on the wall, too. We do not take sufficient account of the fact that this unconscious straightjacket is fundamentally directly opposed to the essence of free expression. Being bound to our own expectations blocks our spontaneity, intuition and freedom, and without freedom our talent does not come into play. It is incomprehensible that, specifically in the case of painting, one of the most expressive means there is, we impose so many restrictions on ourselves, making it impossible ever to reach true expression. So let go of that fixation on models, reality, rules and expectations.

Discover the freedom you have as a painter.

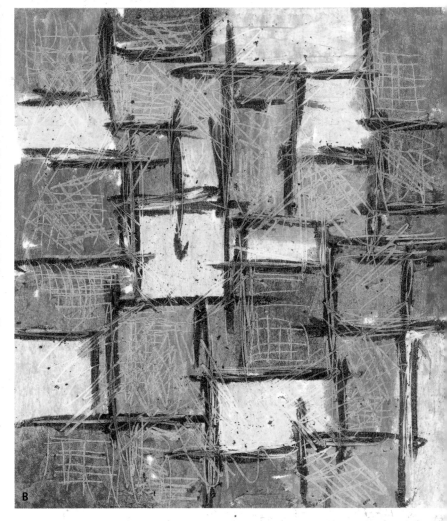

B

■ A Detail of a texture study
Pure acrylic paint is comparable to oil paint and highly suitable for handling in thick layers. When using a knife, it is particularly important consciously to apply variation to avoid one-sidedness. If you do not have a painter's knife, use a filling-knife, kitchen knife, palette knife or a piece of cardboard.

Study tip
• Look for alternative tools, such as a comb, fork, toothbrush, etc., and discover what effect can be achieved with them. Divide a sheet of paper into six or eight sections and make different texture effects in each section using different tools.

■ B Study in oil pastel
It is also possible to experiment with quite simple materials, such as chalk or pencil, on a small format. The intention here was to fill the picture plane with rectangular shapes, to seek colour balance and to play with rhythm, line and texture.

Study tip
• Try freeing up your work even more by using paint on your paper straightaway, without prior drawing. Choose your colours intuitively and follow your instincts. It does not need to be anything and it does not need to become anything. Play with colour.
• Repeat this sort of free procedure, but this time do not make any colour planes, work just with lines in various colours.

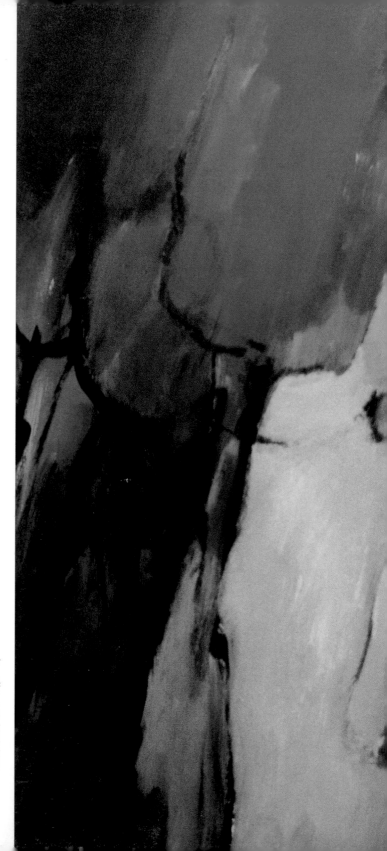

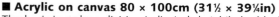 **Acrylic on canvas 80 × 100cm (31½ × 39¼in)**
The basis is a plane division indicated sketchily by black paint. After
that, the primary colours red, yellow and blue have done their work,
with direct colour mixes on the canvas. The diagonal direction of
colour fields and lines gives the picture dynamism and movement.
Harmony is intensified by colour repeats, in fact we come across
virtually every tint again elsewhere on the canvas. There is a strong
contrast in the centre and along the light colour fields, which gives
the work extra suspense and draws our attention. The strong
difference between the deep colours and the lighter planes gives the
effect of light.

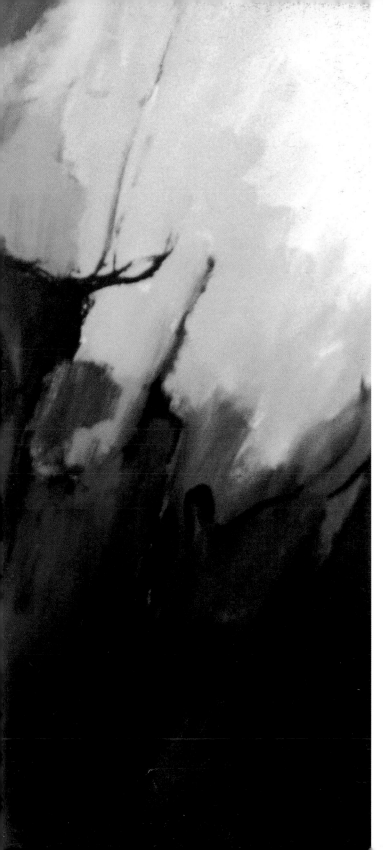

5. Why abstract?

Abstraction has been very deliberately chosen as the pretext for this special method of painting for a number of reasons.

– The abstract procedure allows a fairly direct approach to the essential conditions for painting, since total abstraction is completely reliant on information from our inner being and is therefore in direct contact with creativity, expressiveness, originality and individuality.

This requires some explanation. When you paint reality, your actions are guided by external information. After all, you can see the details of the design, the dimensions, shape and colour in front of you. This information determines your actions. An apple is round, red and yellow, etc. Your feeling for shape and colour is barely consulted, because the desired effect is already visually available. You use only your technical skill to produce on the flat surface what you observe externally.

As soon as you start to work completely abstractly there is no external information available at all. You will have to devise shape, colour, texture and composition yourself. For this you consult your inner resources and therefore work from within yourself.

This is the principle dictating the choice of abstract.

– Abstract painting encourages free and expressive painting, even if you do not yet have a great deal of technical experience. Even if you have never done any drawing, along the abstract road you can nevertheless at least develop your feeling for colour, shape, expression and so on.

– The total freedom of action within the abstract school adds an extra dimension to your painting experience. Because it does not have to look like anything, you feel freer and are more daring. As you are not bound to anything, your creativity is given far more scope.

– Abstract working compels personal interpretation, expressiveness, originality, individuality; a personal pictorial language and style are part of your journey.

– Since there is no object in reality, abstract work is highly suitable for focusing on the pictorial elements that our pictorial language is constructed of. A main feature of the method, therefore, is studying and consciously learning to deal with the abstract elements that together determine our work.

– Because there are no restraints, abstract offers the ideal basis for experimenting, building up technical know-how and experience. Furthermore, such experiments cultivate your own sources of inspiration.

What the abstract study programme offers

If you follow the abstract road you will learn:
– to 'see' abstraction and abstract
– to recognise, apply and consciously deal with the pictorial language
– to develop your internal artistic resources, feeling for colour, harmony, dynamics, texture, etc.
– to reduce reality to the essence and interpret it according to your own ideas
– actually to let go completely of that reality
– to enjoy purely playing with materials, colour, line, shape, etc.
– to let go of self-imposed expectations
– to introduce system to the various abstract options
– to trust your own intuition and spontaneity
– to experiment on your own and investigate techniques and materials
– to develop your own pictorial language and style
– to find and execute your own ideas.

These are skills you cannot learn from a book, just as you cannot learn painting from a book either, but only by your own efforts and motivation. So the effect of the method is completely dependent on the time you are prepared to invest in it.

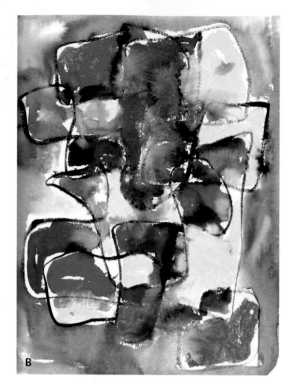

B

■ B Study in watercolour

You can use a scribble as the basis for finishing in colour. You are therefore exercising your feeling for colour distribution and harmony. The scribble here was done with a brush and then finished with watercolour paint in the 'wet-on-wet' technique.

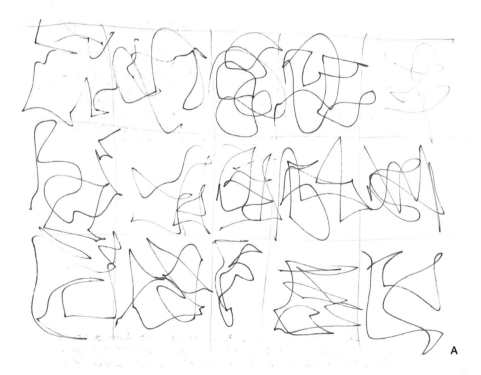

A

■ A The 'scribble drawing' as the basis

A good means of getting away from reality and working freely and without restraint is the 'scribble drawing'. This teaches us to make spontaneous plane divisions, which can serve as the basis for an abstract work. The more spontaneous your 'scribble technique' is, the more surprising and varied will be the way you divide up shape and plane. Here you see a sheet of paper full of scribbles meant as a simple exercise.

What does abstract require of us?

A lot, an awful lot! Abstract is not as easy as people often think, and abstract is certainly not a way of painting to conceal lack of talent and ability. It is actually a very demanding school of painting.

First, it requires far more expressiveness and personal initiative, especially as we are totally without external visual information – as abstract painters we do not have the support of details from reality. We therefore really do have to hunt out everything, and I mean everything, from our fantasy, intuition, power of imagination, knowledge and experience. We have to devise and put together our own composition, we have to design shapes ourselves, tell ourselves where lines go, search for and distribute colours ourselves and decide on textures ourselves. Basically, the how, what and why is produced by ourselves alone and we have to work hard to achieve this. It is not just a case of being *allowed* to decide everything yourself with abstract you *have* to.

In that sense abstract is not exactly easy, but it is enormously challenging, and this is what makes abstract painting exciting. Discover who and what you are and what you have in you: that is what we are going to be working on in this book. So, hesitate no longer, join in and

... go for the challenge!

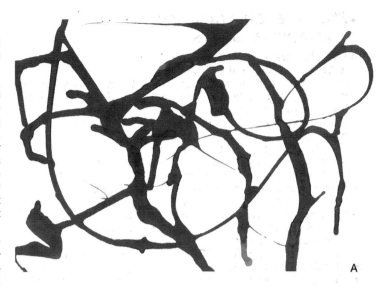

A

Study tip

- Fill a number of sheets with scribbles, using pen, pencil, chalk or two pieces of chalk at the same time. Also put different scribbles in colour on top of one another.

- Try to vary your scribbles with regard to direction, size and shape. Alternate large and small, round and angular movements.
- Choose a few scribbles as the basis for elaboration in colour. You can elaborate a scribble of reasonable size straightaway. If you want to use the plane division of a small scribble you do not have to copy it exactly, which would cause all spontaneity to disappear and your plane division to become wooden. You just make a new, large scribble, following to some extent, at most, the direction of your own example. During the painting process you are of course always free to add or remove shapes or lines.

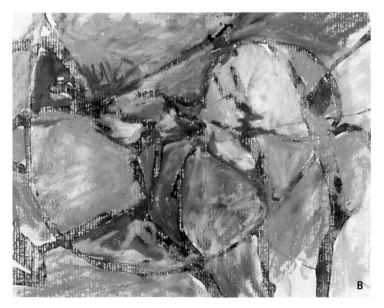

B

■ A and B Playing with line, shape, colour and plane division
Figure A is a scribble in Indian ink from a small spray bottle. In Figure B, the same scribble has been elaborated with watercolour and pastel.

6. Pictorial language

Whether abstract or figurative, a painting is constructed from pictorial elements.

The way in which we arrange them on the picture plane determines whether our work is attractive or not. In fact, we consider a painting beautiful or ugly not on the basis of the representation, but purely on the basis of the effect of the pictorial elements. We generally consider something beautiful because, for example, the colour or the shape appeals to us. Together, all these pictorial elements form a kind of language that we observe on our retinas. Just as letters together form words that we can read and understand, so we can also learn to see, read, understand and sense the visual language of a painting and use it ourselves as painters.

Just as writers make use of words to express themselves and composers arrange musical notes to compose their pieces of music, so painters will arrange the pictorial elements to show who and what they are and what moves them.

Every art form has, as it were, a universal language of its own, chiefly guided by emotion, feeling, nature and character. As painters, we must first make this language our own, even before we actually have something to 'recount', just as we cannot write a song if we know nothing about tone or language.

The writer uses language, the composer works with musical notes, and the painter's tools are pictorial elements.

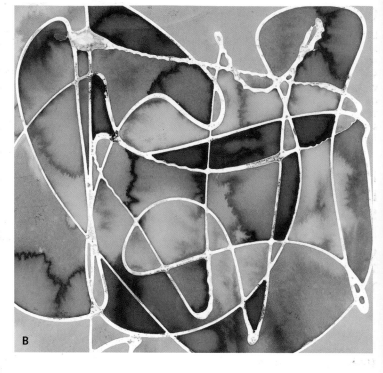

B

A

■ A and B Mixed technique on paper

In order to learn how to deal with our pictorial language expressively and intuitively, we must practise and experiment. The best way to do this is to play with the material and the various techniques.

Figure A is a study with oil pastel and watercolour paint in monochrome colours.

Figure B is an experiment with glue and Ecoline. A scribble drawing was made with glue. Like pastel crayon, glue also stops liquid paint from running.

Study tip

- The more creative the better: playing with line, shape and colour can be interpreted in endless ways. Make several studies, varying shape, line, colour and composition each time.
- Make a study with oil pastel. Use thick contour lines and fill the areas not yet covered with aqueous acrylic or watercolour paint. Find other combinations of materials for yourself.

Our toolbox

Let us open our toolbox and see what is inside. We can divide our pictorial language roughly into a number of primary and secondary pictorial elements or abstract values. The primary ones are the more direct means, the ingredients, as it were, with which we can construct the indirect secondary elements. We differentiate the following pictorial elements.

Primary

Line
Shape or plane
Format
Colour
Tone or value
Texture

Secondary

Movement or dynamics
Pattern, rhythm and repetition
Equilibrium or balance
Unity and harmony
Variation and gradation
Dominance and emphasis
Contrast and antithesis
Dimension or depth
Space and plane division

Composition

Every painting is an arrangement, an organisation, an amalgam, in other words a composition of components from all these pictorial elements.

■ A Study with acrylic paint
As a change from the two previous experiments in cool colours, I here chose the warm colours of yellow, orange and red. This study began with a fairly spontaneous plane division with black lines. The pure yellow came over as too harsh, so I toned it down to light orange.

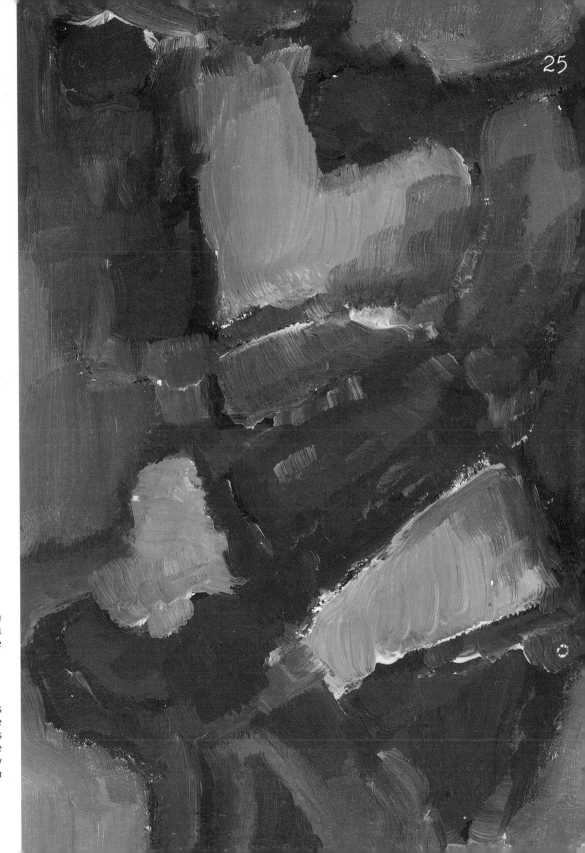

Abstract and figurative painting is the same thing

We can conclude that our painting vocabulary consists of pictorial elements that are the same for every painter, irrespective of style. So it is completely logical to take these same pictorial elements as the starting point for a method of painting.

Becoming familiar with and learning to apply the abstract pictorial elements is, after all, for every painter, beginner or advanced, at least as useful as practising technique. So why is the number of technical lessons on offer so great, while hardly any attention is paid to the components with which we actually construct our painting? It is like selling flatpack furniture without providing screws.

It is additionally apparent that these are the very elements that are particularly suitable for providing system in the multiplicity of abstract options. They give us something to hold on to, which we would otherwise not have in the absence of figuration. They give direction to our programme of study. Abstract painting is not therefore simply muddling along aimlessly, as is often thought: it is specifically the pictorial elements that decide whether a painting has been successful or not. This should make the importance of those elements very clear.

The function of the elements does not, in fact, apply only to abstract work, but also to every other style of painting. Abstract painting is fundamentally no different from figurative or realistic painting. Whatever you paint, you are, after all, continually involved in making choices: what colour shall I use, how do I add texture, shall I use lines or contours, etc.? The only difference is that with abstracts the final painting cannot be named and recognised as a particular thing. 'So what?' For one person a painting must represent something recognisable, while another person would prefer that it did not: simply because we have discovered that our creative ability has more to offer than representing reality alone.

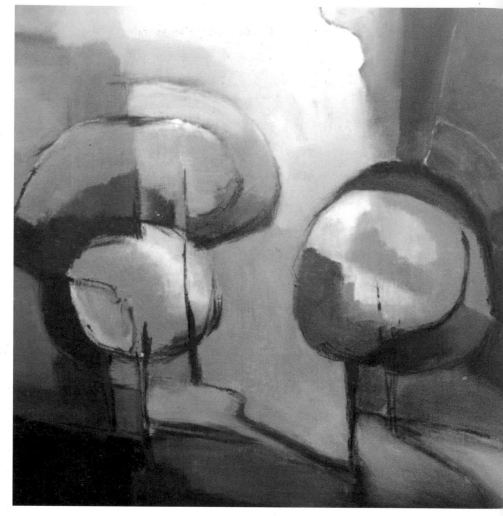

■ Acrylic on board 80 × 80cm (31½ × 31½in)

Much 'abstract' work is derived from reality. Sometimes this reality is still clearly recognisable, but is not entirely realistic. This is usually because we are using shapes that have just been greatly simplified as the theme for a painting. Here I have used, from memory, the idea of a few isolated trees to construct a plane division with alternating round and straight planes. The further elaboration and the colours were completely unrelated to trees.

Training

The painting process itself consists of continually making choices and thinking about the elements used to create the picture. This decision-making process happens largely instinctively, from our internal resources, so it makes sense to strengthen those resources. This is not a superfluous luxury, but a basic condition for achieving artistic work. If we forget to fill those resources, there is little to draw on. In practical terms, this expresses itself in work that lacks imagination and inventiveness, in messing around with the same colours over and over again with insufficient variation. We must make sure we prevent this. It is not lack of technique, but lack of knowledge about and experience of the pictorial elements that is the real cause of despairing remarks such as 'I'm stuck' and 'I want to do something different, but don't know how'. If you are stuck, you will not solve this by buying even more and better materials or practising even more techniques. You can improve your work only by developing the inner emotional aspects that form the basis of the action-reaction pattern during the painting process. Just as an athlete trains his physical and mental talents, you, as a painter, will have to train your artistic abilities. Getting to know and using your basic tools, your pictorial language, constitutes an important first step in this.

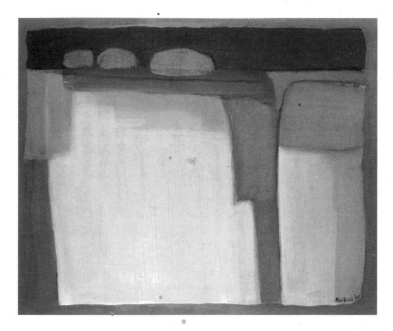

Study tip

- Look for a photograph of a landscape and try to reproduce it as abstractly as possible. Indicate the main shapes with contour lines. Try to see everything as a flat surface, and use as many 'unnatural' colours as possible.
- Repeat the assignment with a different subject from reality, such as sailing boats, a wood, a townscape, a pile of boxes, flowers, whatever you come across.

■ Acrylic on MDF 40 × 40cm (15¾ × 15¾in)

Continuing the idea of landscape, this time reality has been placed in a rather strange perspective. In the top part, it is as if we can see trees or houses standing out in contour against the sky. In the rest of the painting it seems as if we are floating above them, looking down on ditches and fields. This unusual view of the landscape is one of the many ways of distorting reality, yet still seeing it only as abstract shapes. The strictly horizontally and vertically aligned areas give a static effect, creating, together with the solid colour planes, a restful picture.

7. **Play**

Study method

We can say that the pictorial elements are our tools and that they are guided by our internal resources. So how do we reach the point where our internal resources can, and actually do, guide us in this way? Very simply: by gathering knowledge and experience and practising a lot. So, work on your feeling for line, shape, colour and composition. Learn, on this foundation, to make intuitive use of the pictorial elements as the building blocks for each painting.

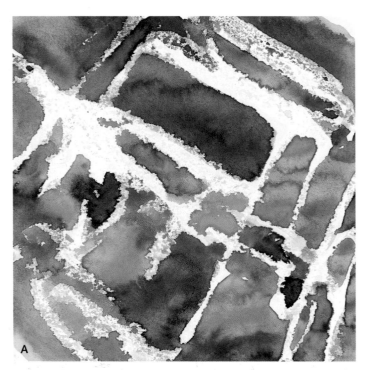

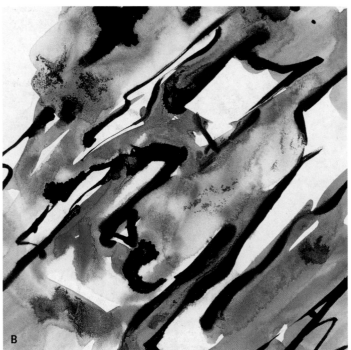

■ A and B Playing with materials and technique

In order to stimulate our painting skills and creativity, it is more sensible to go ahead and experiment than to aim at making a more or less successful painting. We must accept that practising and studying are our first priorities, and that in time presentable work will automatically come from that. Figure A is a study with paint-resistant candle-wax and watercolour paint. Figure B is a combination of Indian ink and watercolour.

Study tip

- Get out all the materials you have. Choose two each time and try to combine them, e.g. ink and acrylic, pencil and watercolour, pastel and felt-tip, charcoal and – you decide.
- Investigate the technical possibilities of each material and experiment with them all.

Play

The very best means of activating your own resources is play. Play is the most open and uninhibited way of learning. It gives us the opportunity to reach our inner gifts and talents, especially if we are able to act on the basis of spontaneity.

Play is unrelated to any previously determined result. It comprises complete freedom of action, giving scope to every kind of inspiration, intuition and imagination. Play is the domain of children, having been forgotten by many adults and replaced by rational, purposeful action.

As an already experienced painter you may have some difficulty with the 'freedom' of play. Letting go of your own expectations is hard, but it has to be done. You will definitely benefit from it. So learn how to play again. It has nothing to do with childishness, and everything to do with reaching and activating your inner resources.

Play gives impetus to characteristics that are of great importance for the development of artistic qualities, not least because as adults we have forgotten what play can release in us. Playing is:
– experimenting, discovering, investigating and learning
– healthy curiosity
– what matters and surprising yourself
– trusting in yourself and learning to appreciate yourself
– spontaneous and intuitive
– fantasy, inventiveness and imagination
– fun and forgetting everything around you
– not tied to results and therefore free of stress and pressure
– contact between your inner and outer worlds
– unrestrained, creative, expressive, original and individual
– a mix of gifts, talent, knowledge and experience
– effort, motivation, involvement, passion and enthusiasm.
No other kind of exercise activates as many qualities as play. The value of play as a way of learning therefore goes without saying, and deserves to be regarded as a valuable method of study.

Play brings out what lies within (you).

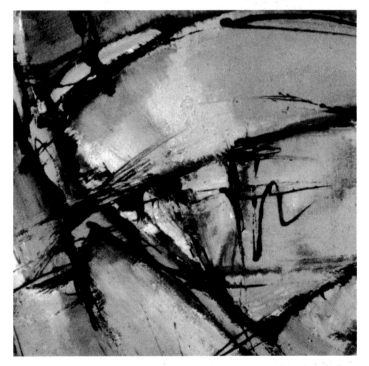

■ **Acrylic on canvas 60 × 80cm (23½ × 31½in)**
Detail of an elaborated study based on play with line, shape, colour and mixed materials. Acrylic and Indian ink were used here.

Pictorial elements provide abstract with something to go on

To give our play structure and direction, the abstract method couples play with the various means available to us as painters: the pictorial elements, composition, technique, material, idea and theme.

Just as the figurative painter has the details of reality to go on, so the abstract painter has the pictorial elements. Those pictorial elements can be the basis for our practice programme. Moreover, they are sufficient to act as an independent subject and starting point for an abstract painting. So there really is something to go on for abstract painters too.

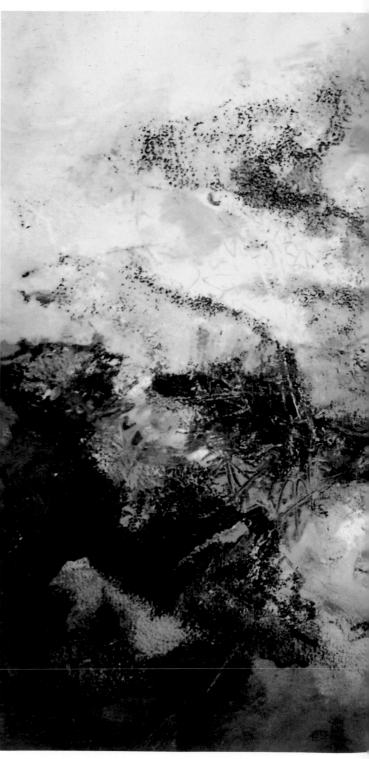

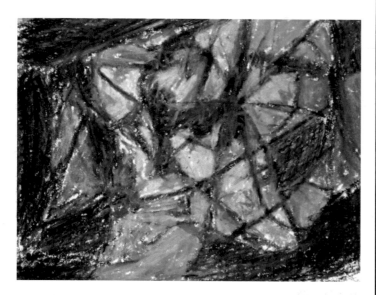

■ Study with oil pastel

When making a material study, working fully abstractly is the best way. We can then concentrate fully on the qualities and possibilities of the material. This study should be regarded as a play with line, shape, colour, texture and material.

Freedom in restraint

Although play assumes freedom, it does not benefit from lack of direction. It may sound contradictory, but freedom thrives on restraint. Every game has variously defined rules. Their function is not intended as compulsion, but as something to lean on. When using the play method, it is important to give ourselves direction in our play activity so as to prevent us from just muddling along with it, since the effect of playing turns out to be greater if we associate it with limits and restrictions.

Imposing certain limits on a study exercise steers our creative thinking in a particular direction. This restriction forces us to dig deep in the given direction, which may lead to new discoveries. Without direction, and therefore with a profusion of options, we search more superficially and are more quickly inclined to look for yet more lines of approach. Admittedly, this gives a broad outlook, but as far as depth is concerned, it misses the mark. Limits encourage more intensive exploration. Diversity confuses and diffuses our energy. In this way, we demonstrate that direction and limitation activate our creativity more than does superficially wandering about among an overabundance of alternatives. This is the cause of various problems I have come across as a teacher during my lessons, and is one of the reasons why I almost always formulate the content of my lessons around a limited number of facets of the painting process.

■ **Acrylic on canvas 80 × 80cm (31½ × 31½in)**
A work based on the pictorial elements of colour and texture as an autonomous theme. First, a texture layer was applied to the canvas with gel and rough sand as an extra filler. Once everything was dry and had hardened sufficiently, the work was further elaborated with colour. There are no obvious delineating colour fields because the elements of line and shape are missing.

Study tip

• Try to do the exact opposite of the figure on the left. To do this you must first analyse the work on the basis of the pictorial elements: it is a work without lines, so in your study you must use lines; the shapes are irregular and not delineated, so what must you do now? The colour is monochrome, therefore…

8. Abstract and abstracting

What is abstract?

If we choose abstract as the starting point of our method, it makes sense to find out about the essence of abstraction and to know how we can make use of it.

The dictionary gives the following definitions.

Abstract (Latin *abstractus*) = removed from reality, unconnected to what is observed, intangible, not able to be represented as a shape, unable to be named as an existing, concrete thing.

To abstract = to take away, isolate, remove from what is perceived.

Abstract art is described as art which has no recognisable relation to visible concrete reality. It uses elements such as shape, colour and line to create its own reality. It is also referred to as non-representative, non-figurative or non-representational.

Abstract can therefore have a distant link to reality because it is derived from it. It can also arise purely and simply from the abstract pictorial elements, the domain of total abstraction. There are, however, a large number of abstract-oriented art trends, in which reality is actually the starting point. The extent to which reality is still recognisable determines whether we can define it as figurative art or non-figurative or abstract art.

Within abstract painting, we therefore have two starting points:
1. **There is a relationship with reality.**
2. **There is no relationship with reality.**

1. If we use reality, our work is based on external information.

We are then dealing with a representation; it can be named, it has a name. It can be recognised, albeit sometimes vaguely, as something that exists and gives both the observer and the maker something to go by. For example, we can observe aspects such as colour, shape and texture and act according to them. In other words, things from outside have an influence on the painting process. Direct visual information is used and interpreted by us.

2. If we do not use reality, our work is dependent on internal information.

We cannot give it a name, it is not recognisable as anything in particular. It literally does not look like anything, i.e. it cannot be judged on external comparable criteria. A comment that is frequently heard from people looking at completely abstract art is 'I don't know what it is, it doesn't represent anything'. No, it does not represent 'something', precisely because that is not the intention. Such work arises entirely from one's own imagination and feeling because there is no relationship with reality. So, as painters we are totally dependent on our instincts, our pictorial language, the abstract pictorial elements and the qualities of the material with which we are working. Between point one and point two there is a huge area of painting characterised by abstraction.

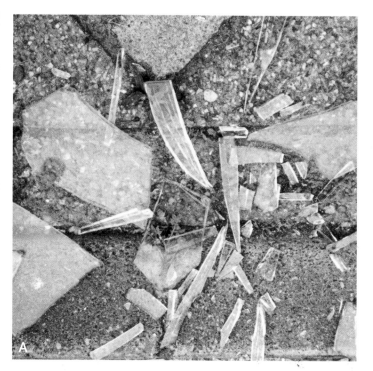

A

■ A, B and C Reality as incentive

We must interpret reality as broadly as possible. What is important is that we develop a certain sensitivity that enables us to be inspired by unconventional details. For instance, an accident with a piece of glass gave me the idea of using the broken shapes and splinters as the theme for a painting.

■ B Mixed technique

I did not intend to use the glass shapes from Figure A as a composition. Therefore I had to devise them for myself and pay attention to variation, focal point, direction and dynamics. Figure B is just one of the elaborations I did on the basis of this theme.

■ C Nature as a stimulus

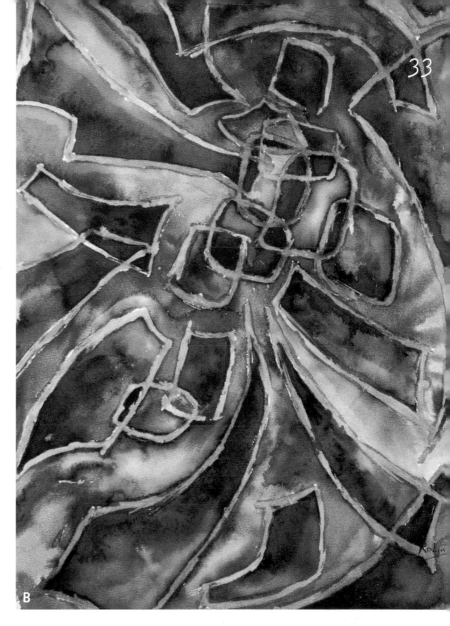

Study tip

- Make a series of studies using Figure C as a stimulus.
- Find your own photograph and make different studies of the theme. It is always sensible to elaborate a particular theme in different ways in a series. It gives you the opportunity to investigate an idea thoroughly and extract from it what it contains. If you do not do this, your work will remain too superficial and you will soon run out of ideas.

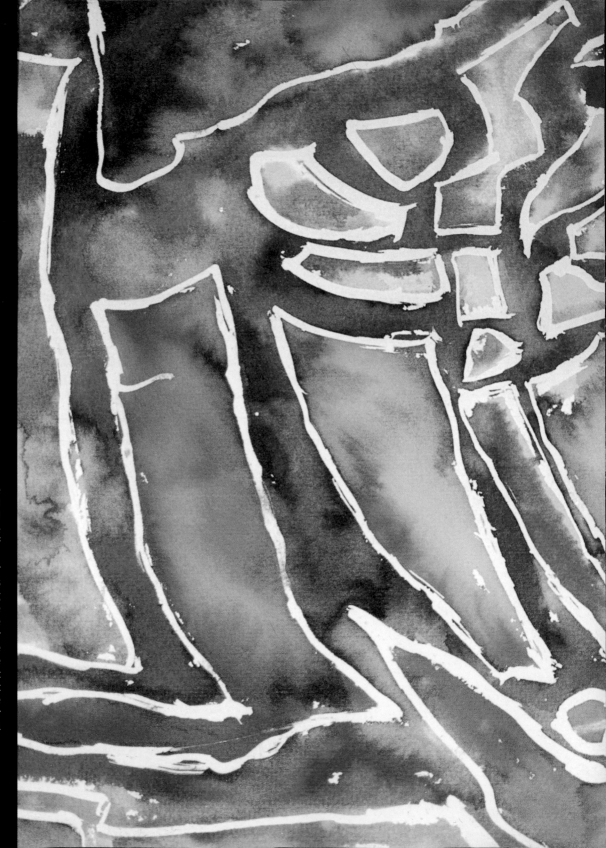

■ **Ecoline on paper**
50 × 65cm (19¾ × 25½in)

A work inspired by the theme 'broken glass'. The shapes and the plane division are covered with masking film. The composition consists of separate, closed, free shapes, varying in size. The colour infilling between the shapes acts as a linking factor, creating cohesion between the separate parts and the 'background'. The rhythm of the white contour lines divides and accentuates the shapes. The entire picture plane has been filled. The shapes at the edge are open and suggest that they continue beyond the plane. Colour harmony, colour contrast and brightness give it a powerful aura.

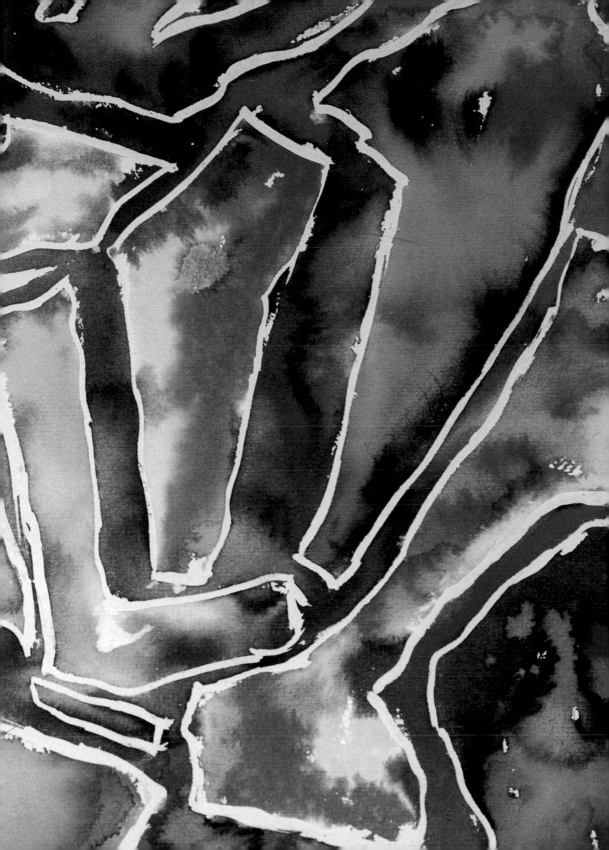

Abstraction

When as abstract painters we set out from reality, we will mainly use abstraction, making reality more abstract to such an extent that recognisability scarcely comes into it. This is a method in which we use reality, but do not copy it. It is a more challenging way of reproducing the things around us in our own way.

Reality now acts only as a stimulus. We no longer let ourselves be dictated to with regard to which shape or colour to use, but allow ourselves the freedom to create our own new reality. So, as far as possible, deliberately push aside all those rules you have learned about shade, perspective and depth; throw the details based on reality, such as colour and shape, overboard. They restrict our freedom and belong to a style of painting that is not relevant to us at the moment – so get rid of them, because the sky can be green and a horse blue, apples square and trees triangular. Basically, do something mad for once, dare to be provocative,

dare to create instead of copying.

From reality to abstraction

When we use concrete reality, such as a tree, flower or landscape, to abstract, we can take the following steps:
1. Leave out all the details.
2. Leave out all the depth aspects, such as shade and perspective. Consciously go back to a two-dimensional reproduction.
3. Simplify the shape by stylising it with rigid, fanciful or angular lines.
4. Deliberately change the colour to other, non-realistic colours.
5. Reduce the whole to a few outlines and shapes.
6. Compose your own unconventional or unnatural composition.

Ultimately so little of the original reality is left that you can easily separate the subject from its function. In this way you have reduced reality to abstract shapes that you can use as the stimulus for your play, study or painting. None of the reality with which you originally started out will now be recognisable in your work. The extent to which you carry out this process determines whether the work is still regarded as something recognisable or as abstract. The further you deviate from reality, the more you approach total abstraction, the greater your own input becomes and the more scope there is for creativity and expressiveness, originality and individuality. Even as a figurative painter, you will benefit from the abstracting method, since you are forced to look at your subject in a different way and learn the art of simplifying. Look for the essence and accept that it can and may be different! Too often I still hear the comment: 'Yes, but that's how it is, so can it be any different?' Yes, of course, it can because you set your own rules!

■ Preliminary study on paper
If we paint abstractly and use reality, we can distort it in such a way that nothing recognisable remains. We also have the choice of actually retaining something recognisable. I once made a study in acrylic on paper inspired by a group of trees against a sky that was strongly coloured by the sunset. I did not do the sketch on site but from memory and my powers of imagination.

■ Acrylic on board 80 × 80cm (31½ × 31½in)

Inspired by the sketch on page 36, I have elaborated the idea in the colours red, yellow and black, a combination with a great deal of contrast. The actual situation was by now no longer important.

Study tip

- Place an object in front of you and follow the path of abstraction from step one to step six as shown on page 36.
- Repeat this using a photograph. In this way, you work from reality to complete abstraction.

From abstraction to reality

It is obvious that the opposite of abstraction is also possible. Many painters begin with technical experiments without any aim or figuration. The results of spontaneous play with materials and technique then form the basis from which figurative pictures can emerge. Or else painters let themselves be inspired by the result of their experiments: they see in the multiplicity of textures and effects something that resembles a landscape, a flower or an animal, for example, and decide to elaborate the painting around that theme. On this road, too, the abstract method is a source of inspiration. A spontaneous start that results in a surprising sequel is particularly stimulating, and an absolute must for your programme of studies.

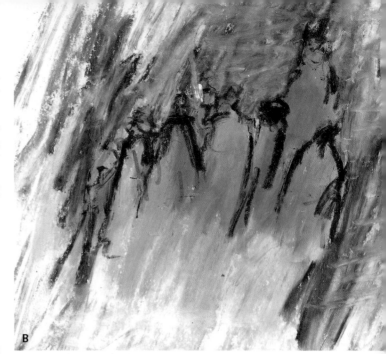

B

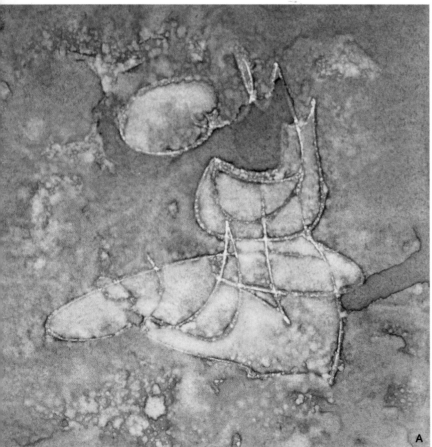

A

■ A, B and C Playing with line, shape and theme

These are three examples, using different materials and methods of construction, around the common theme of the human figure as an abstract form.

Figure A This study in watercolour and chalk arose from a spontaneous scribble drawing that reminded me of a sitting figure.

Figure B This is a study in oil pastel. Open colour fields have been applied with scratching movements. The orange colours in the centre have attracted the attention in such a way that they have become the inspiration for placing sketchy figures in contour over them with black chalk. The group of 'people' provides for a fairly central focal point.

Figure C This is completely different in layout and materials. Randomly torn pieces of newspaper were stuck on to the ground, then aqueous transparent acrylic paint was used to add colour. I deliberately chose transparent paint because I wanted the texture of the print pattern on the newspaper to remain visible to some extent. After it had dried, I drew over it in ink. This experiment is waiting to be further elaborated at some stage.

Visual or mental

If you choose reality as the source of inspiration for your abstract or abstracted work, there are two different ways of starting.

1. Starting from visual information The concrete reality is visually present: you can see the subject of your painting. The subject is in front of you or is visible by means of a photograph. You look and gather visual details, such as shape, colour, texture, plane division and composition. You interpret this in your work according to your own ideas. With this method we get to know reality. We must therefore fill our visual memory, the reservoir for our powers of recollection and imagination.

2. Starting from mental information The concrete reality is not visible but present only in recollections. You consult your memory and visualise the subject in thought. In doing so, you will have to call strongly on your powers of imagination. The picture you are conjuring up is now far less detailed than if it were standing in front of you. Without noticing, you are already well on your way to abstraction, because you are far less concerned about and guided by the details of reality. In addition, deviating from and changing the subject is much easier if it is not directly visible. In the abstract method we give preference to this latter line of approach because it makes it easier to come closer to our goal.

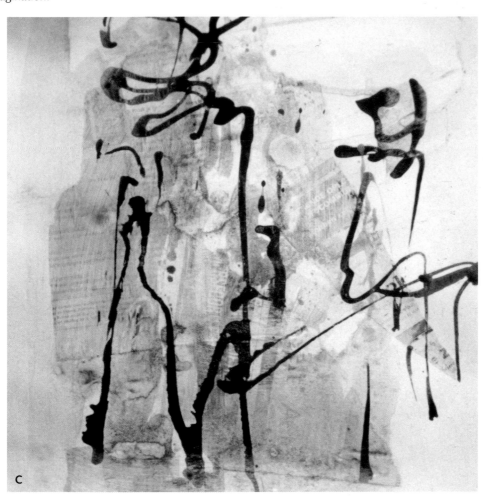

C

Study tip

• Try both starting points. Paint a landscape or still-life from memory, in other words from mental information. You are then working on the basis of your own powers of imagination and will automatically reproduce fewer details.

Study tip

• Now make an abstracted study of something that is directly visible, for example the view from your window, a still-life of your painting materials or a photograph. You are then working from visual information and decide yourself how far you want to deviate from reality.

Stock-in-trade

In order to be able to use mental information, your memory needs to possess the necessary stock-in-trade for your powers of imagination to get to work. You have to have seen and studied something at one time to be able to visualise it internally. Visual and mental reality are a continuation of one another, and we therefore need that reality initially in some form or another. Gather as much stock-in-trade as possible by regularly studying reality, so that you have it sufficiently ready and waiting for you to work with it abstractly and expressively. If you paint reality from memory, but do not know it well enough, it almost always leads to amateurish picture formation. You fail irrevocably.

Abstract painting is not intended to conceal a lack of background. If, for example, you use the human figure in your work, do it only if you have studied human posture, proportions, body language and shapes. Without this knowledge your human figure, whether abstracted or not, becomes a shapeless, meaningless reproduction of an essentially meaningful subject. Regular study of reality inherently increases your powers of imagination and skill of expression. This need for stock-in-trade and background also applies to painting subjects with a more emotional content. I sometimes see work in which the spiritual content and depth are completely devoid of power because the painter does not have the experience, and therefore the stock-in-trade, to reproduce something of that sort with conviction.

Study tip

- Make a study inspired by your latest holiday. What is the first picture that comes to mind? Try to paint it.
- Now paint the same idea again, but make it more abstract.
- Make a free composition with objects from reality without being able to see them, therefore from memory. Paint a pile of hats, a basket of tools, a table with kitchen utensils on it, or a harbour with boats, for instance. Possibly repeat them with other materials and in an even more abstracted form.

A

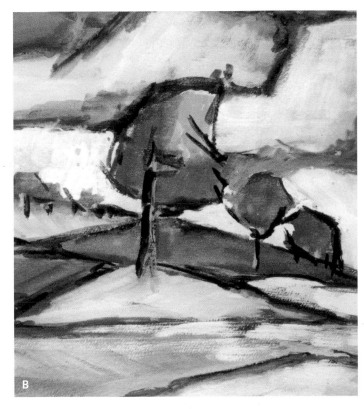

■ A, B, C and D Play originating from mental information

Ideas for shapes may come from our memory. This works only if we have once seen that 'something' and have therefore stored it in our memory. Here are a few examples of work that arose from mental information. The ideas have been used at the same time to try out different materials.

Figure A is a work in watercolour inspired by the idea of little jets of water and condensation on windows. The wet-on-wet technique was just right for the idea. You must have seen something like this once to be able to reproduce the right atmosphere and to match technique and materials to it.

Figure B is a gouache of a landscape elaborated in a slightly cubist manner.

Figure C is a study based on the play of branches of a bare tree. The emphasis lay on the plane division and a smooth, even colour surface.

Figure D is a work in acrylic on canvas. The bluey green colour gets support from Naples yellow for the lighter tone accents. The diagonally aligned play of lines emerged here from the idea of a bouquet of flowers.

There was never a desire to reproduce reality itself. It is specifically when we work from memory that we can easily let go of details and limit ourselves to the essentials. As a painter you have the freedom to use what you think necessary and to leave out the rest. Take advantage of that freedom.

Language of abstract shapes

When you dare to use complete abstraction, you are using a non-representational language of shapes that we can roughly divide into five groups.

1. Geometric shapes These are rational and are devised by us. Squares, rectangles, circles, etc. are the basis for geometric abstract art, as in constructivism.

2. Symbolic shapes These are pictorial symbols with a decorative function, some of which are also associated with a particular meaning. These elements also appear as a strong presence in cultures where not only art but also clothing, houses and utilitarian objects are decorated with traditional symbolic shapes.

3. Organic shapes These are free shapes, present in nature, that are visually perceptible but are used purely as abstract shapes. We can discover organic shapes in rock formations, stones, microscopic organisms, etc.

4. Free shapes These are expressive, fanciful, variable shapes created by a spontaneous painting process, as in abstract expressionism.

5. Shapelessness There is no particular 'self-contained' shape. It is a joining together of expressive colour nuances and painterly effects, mostly originating from free experimentation with materials and technique. The act of painting itself creates the desired result. We can see this in the work of the matter painters, action painting and the colour field paintings.

■ **Acrylic on MDF 40 × 40cm (15¾ × 15¾in)**
This is a carefully constructed composition based on geometric shapes. These are self-contained, delineated shapes, which are given extra accentuation by the black contour lines. There is a strong focal point created by the small, grouped colour planes. The colour repeats round the edges pull it all together. Cohesion and harmony are produced by colour and line.

You could say that there is still some restraint in group one, but that maximum freedom is achieved as you descend to group five. If we compare the two extremes, a kind of antithesis emerges within the abstract school:

Geometric abstract art	Expressive abstract art
Cerebral	Emotional
Objective	Subjective
Universal	Individual
Rational	Expressive, spontaneous, impulsive
Systematic arrangement	Improvising
Order	Chaos
Purely geometric shape language	Unpredictable, fanciful shape language
Controlled use of colour	Unrestrained use of colour
Logic as basic principle	Association and automatism as *Leitmotif*
Trends include constructivism, concrete art, minimal art, systematic art, symbolism.	Trends include abstract expressionism, action painting.

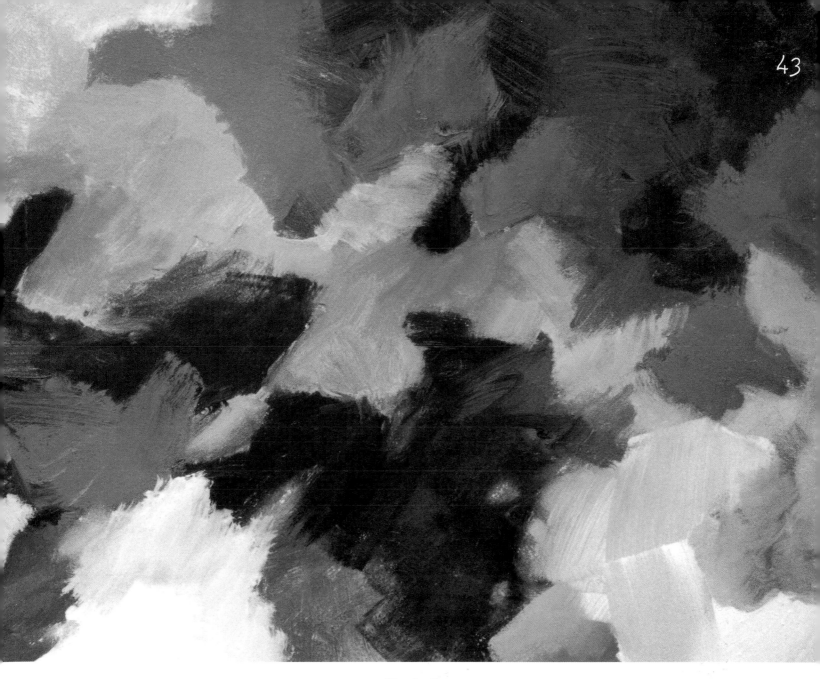

■ Acrylic on canvas 100 × 120cm (39¼ × 47¼in)

A spontaneous, dynamic composition, consisting of free shapes without any delineation. Every colour plane is thus given space and develops during the painting process on the basis of intuition and improvisation. Free shapes are also generally more expressive, because in making them we normally use a rougher brushstroke and structure our work more actively, making it more striking. Contrast and brightness of colour really draw the attention here. Repeats keep our eye on the move, and make for cohesion and harmony.

Study tip

- Both methods deserve our attention. Construct a well-balanced plane division with geometric shapes. Use cut-up pieces of coloured paper for this. Stick them on and use this as the basis for a study.
- Repeat this collage-like structure with free shapes by working with torn paper.

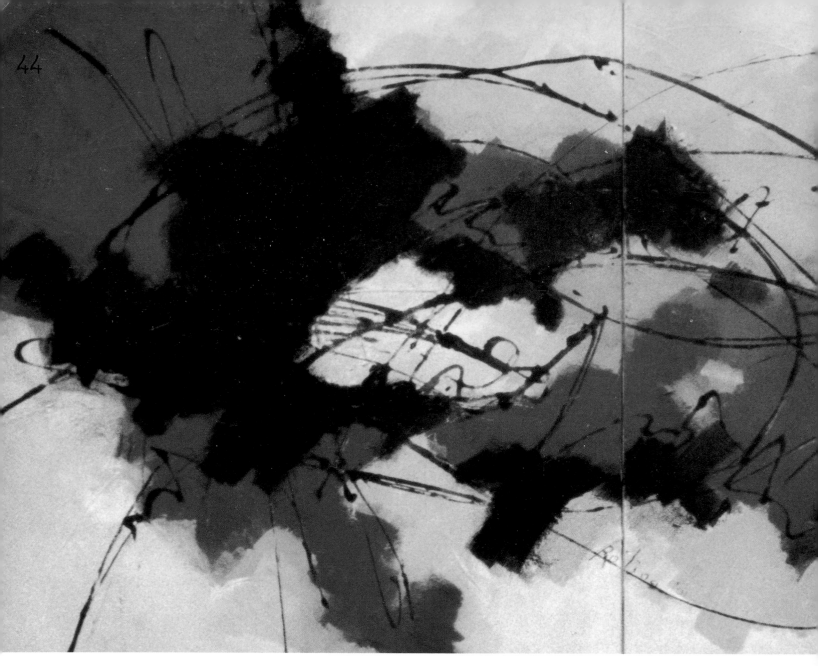

■ Acrylic on canvas two 80 × 100cm (31½ × 39¼in)
This is a clear example of playing with the pictorial elements. Free expression sometimes seems to need a large format, giving scope to the large painting gesture. If one piece of paper or canvas is not enough, simply use two. Large arm movements starting from the shoulder literally bring dynamism to the canvas. Take a large brush and paint the planes from the shoulder with outstretched arm. You will certainly not get the chance to worry about details.

Study tip

- Design your own composition and try to execute it in three different formats: small, medium and as large as possible. You will find that your technique will have to fit in with the size of the support material.
- Also, do the experiment with a different size variation, e.g. square, wide and short or tall and narrow. The composition and plane division in question will now need to be adapted.

9. Primary pictorial elements

Pictorial elements can make or break our work

Whether you are painting figuratively or abstractly, you cannot avoid them. The pictorial elements ultimately make your work striking, attractive, interesting, exciting, varied and dynamic, or boring, lacking in imagination, stiff, amateurish and monotonous. One by one, each in their own way, they play a part in defining your picture. They determine whether there is quality or mediocrity, whether we succeed in making it art or not – a good reason to investigate further.

A closer look at the primary elements of line, shape, format, colour, tone and texture

This may seem slightly superfluous, because everyone knows what line, shape and colour are, of course, but practice has taught us that we are often very wide of the mark. Our knowledge and experience are sometimes so limited that we have unconsciously nurtured an ideal feeding ground for unimaginative traits and one-sidedness.

For instance, the element of line is often used solely as a contour line to indicate shapes or to make a particular plane division. This means that line is reduced to an inferior device, whereas it actually has far more to offer. Many works fail because they lack variation in colour and shape. The elements of tone and structure could also do with a boost sometimes.

Line

The line from device to lively element with power of expression

Nine out of ten times we use a line only as a contour or plane divider. If we confine ourselves to this, we are doing ourselves and the element of line an enormous disservice. The line is far, far more than a subordinate device. It is in fact one of the most influential of the illustrative means. We will now examine a number of aspects of line.

The line does not exist

In reality the line does not exist. A tree, apple, stone, surface or shape is not surrounded by a line. We know only the transition from one plane to another. We can indicate the horizon by a line, but in reality there is only a visual transition from the bottom area to the sky part. The line is therefore not a reality but a purely abstract detail.

The line as a drawing element

The element of line is imagined by us. It acts as a drawing aid that enables us to indicate shapes, plane division and linear effects on the two-dimensional surface.

The line as contour

Contour is the boundary and outline of shapes we want to indicate on the flat surface. A contour drawing can act as a support to give the later painting direction. In that case, the line is only an aid and not an illustrative element. However, as soon as we use the contour line to give extra accentuation to shapes, the line does, in fact, act as an illustrative element. The contour therefore enables us to visualise recognisable or abstract shapes. The nature of the line ultimately indicates whether we want it to act as an aid or as an element defining the picture.

The line as plane division

If we use the line to make a plane division, it is acting as an aid to composition. In this case, too, the line may well be upgraded to a picture element. If, like Piet Mondrian, we give the line great bulk and power, it becomes an equally serious picture-defining element as the planes and colours bordered by the line. As soon as the line is present expressively, it plays an artistic role and in this way influences the entire picture.

The line as an autonomous subject

Particularly in the abstract school of painting, the line is a strong tool. Many abstract works are even based exclusively on the element of line. Therefore we should certainly not ignore line as an autonomous subject when playing with the pictorial elements. You should, as a stimulus, fill a page with linear experiments every now and then. In this way, you create your own abstract objects and you get to know the autonomous value of the resource 'line'.

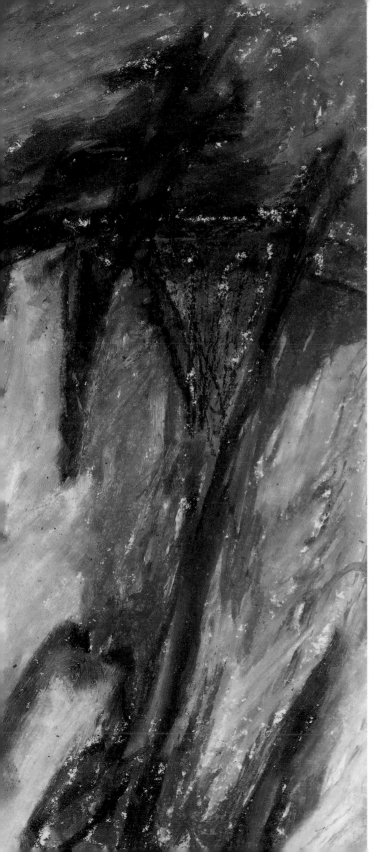

■ Study in oil pastel

This composition has been conceived with broad contour lines. Although they act as a plane division, they also play a dominant picture-defining role because of the black of the lines.

Study tip

- Try to draw the contours of a boat, a flower, or an animal, for example, outlined with a line. You are thus working from observation. Your hand is, as it were, following your eyes as they wander round the object.
- After you have drawn something from observation several times, repeat it from out of your head, therefore from memory. Check whether you have gathered enough stock-in-trade.

The line as the basis for the other pictorial elements

The line is also important as a means of producing the other pictorial elements. As well as indicating shape and size in contour, by applying hatching the line can deepen colour and translate colour into tone. Linear actions can produce texture in a great many ways. The line can give direction and therefore produce dimension, depth, dynamics and movement. The line can divide the picture plane, but also ensures cohesion, unity and harmony. The line can emanate symmetry, balance and calm, and play a role in producing variation, rhythm, pattern, accent and contrast. If we wish to start using the line with that goal, we must go deeper into the abstract values and the technical possibilities in order to achieve them.

Line technique

1. Linear action Every linear action produces a pictorial symbol. We call it a line or stripe, irrespective of colour, direction, length, thickness or the way it was created. The more variations we can discover in it, the greater is our arsenal of expressive options. Too often we confine ourselves to materials like black pencil, chalk, ink or paint. In this respect, in particular, there are dozens of different variations available to us, and playing about with them can teach us a great many more.

2. Linear effects Lines or stripes can also arise without linear action. There is a large number of techniques that produce stripy effects. Here, too, we can increase our options by experimenting with printing techniques, blowing and flow techniques, stencilling and pouring techniques, etc.

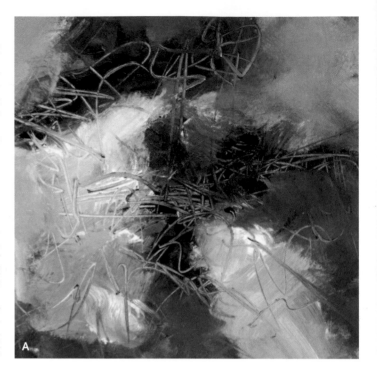

A

Study tip

• Experiment with the linear effects that result from the techniques described above.

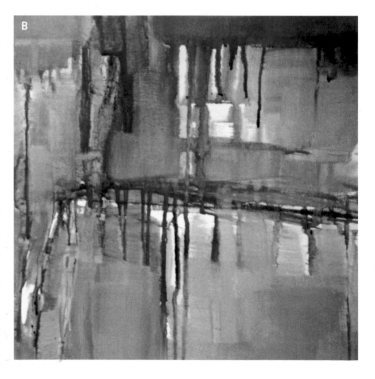

B

■ A, B and C Playing with line and colour

Three examples in which lines have an important function. Each has arisen in a different way.

Figure A This is a study in acrylic. The line has been created by scratching with a sharp object in the thick layer of paint. Such line effects give our work texture, action and spontaneity.

Figure B This time the acrylic paint has been made liquid with a large amount of water, and stripe and line effects have been created by letting the paint run and drip.

Figure C This is a study in watercolour. We normally use black lines, so that is why white has been chosen this time. You can make white lines by using white paint or by leaving gaps in the white of the ground with water-resistant material such as wax crayon, glue or opaque film.

Line as a decorative element

A line can be thick, thin, clear, vague, angular, curved, fragmented, dynamic, static, powerful, hesitant, searching, direct, descriptive, broken or constant. In this aspect in particular, experience in variation and gradation based on spontaneity is of great importance to bring to life boring, monotonous, mechanical line-making.

This is where the line finally starts out on its road to expression. It is up to us to put everything possible into it.

The emotional line

Whether lyrical, aggressive, calm, vigorous, sensitive, concise, enthusiastic, playful, conscious, unconscious, spontaneous or intuitive, the line ultimately becomes the painter's signature, his or her tool for individuality, expressiveness, spontaneity and originality.

The line as a reflection of the personality

Are you a hasty type of person or calm and cautious? Are you untidy or a fusspot, a dreamer or a blabbermouth? If you let the line develop expressively, intuitively and spontaneously from your inner being it will imperceptibly be a reflection of your character. Just as our signatures are useful sources of information for psychologists, so can character traits be revealed by drawings. As a painter, you can lay bare your entire heart and soul using the pictorial element 'line'.

The line is lively and vigorous; it activates the mind, not by telling a story, but by the feeling on which it is based.

■ D Line study

In order to investigate all the things that are possible with the element line, it makes sense to fill a sheet of paper with line experiments.

Study tip

• Make a number of line studies based on colour.
• Make line studies based on rhythm and repetition.
• Divide a piece of paper into 16 sections, and in each put variations of lines: thick, thin, straight, round, squiggly, etc.

Shape or plane

As well as line and colour, we nearly always use the element of shape or plane. Together they constitute the most obvious ingredients, which we have understood since childhood. We learned them at our mother's knee and each has a strongly communicative function. This makes them the most striking visual pictorial language we can have.

The pictorial element of shape or plane:
– is present in almost every painting
– has a strong compositional function
– defines the spatial division of the picture plane
– can be either two- or three-dimensional
– easily acts as the subject of a painting
– influences the secondary pictorial elements
– has various manifestations and qualities
– can be produced in many technical ways
– varies from concretely recognisable to completely abstract.

Concrete shapes

If we want to use reality, the shapes we put in can be specifically and objectively named as a flower, tree, mountain, and so on. The shape is then used to achieve something recognisable. The shape to be reproduced is dictated to us from outside. For instance, a tree has a narrow part, the trunk, and a round part, the crown. Moreover, we are bound to the function, size and place of the object: a cloud will always be placed in the sky section; a tree on the ground section; and a gate will usually be smaller than a tree, and so on. Even if we use reality strongly abstracted, concrete restrictions will still involuntarily influence us. Therefore we prefer to work with abstract shapes.

Abstract shapes

The abstract shape cannot be named and is free of any function, place definition and/or format. There are no restrictions from outside, but neither can any support be expected from it.

This is precisely the reason why input, intuition, feeling, imagination and creativity are so terribly important here. As abstract shapes we can use **geometric, symbolic, organic** and **free shapes** (see page 42, the language of abstract shapes).

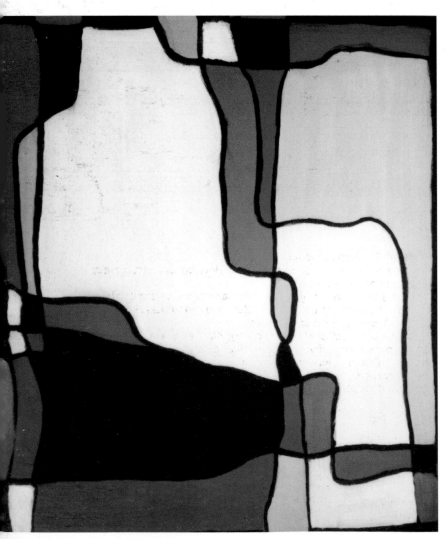

■ **Acrylic on board 60 × 80cm (23½ × 31½in)**
A composition following a structural path sometimes produces rigid geometric shapes. With a design like this we usually make a number of sketches first, in order to arrive at a balanced division. A neutral colour combination with plenty of contrast options has been chosen for the elaboration.

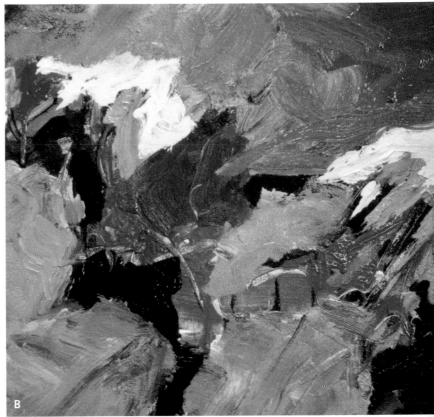

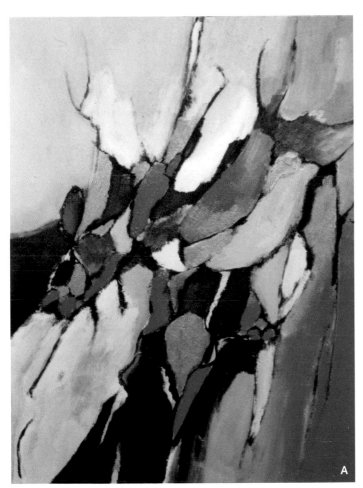

■ A and B Shape technique

The way in which we allow shapes to develop can vary greatly depending on our aim.

Figure A shows more delineated, rigid free shapes surrounded by a contour. This gives separate colour fields, which in this case have also been presented as even and smooth.

Figure B is a textural study based on organic shapes: the remains of leaves on the theme of autumn. Here the shapes are rough, textured and unbordered. Coincidental colour mixes also play a decisive role. The study has been composed with the 'alla prima' technique, direct and with thick paint.

Study tip

• Make a study with geometric shapes, triangles, circles and/or squares and rectangles.
• Follow this up with a study with completely free shapes that develop as you paint.

Concrete abstract shapes

I would like to draw your attention to the many ideas about shape you can discover if you are able to learn to see reality in an abstract way. Personal discovery of abstract shapes succeeds only if you learn to observe on the basis of the pictorial elements. This does take a certain amount of training and a sensitive mind, however.

The things around us attract our attention by the signals they send out. These signals start out from the abstract values, in other words the pictorial elements, because colours, shapes, patterns, rhythm and contrast are ultimately the factors that attract our attention. A sunset may be attractive, not because the sun is nearing the horizon, but because the pictorial elements of colour, light and contrast appeal to us.

It is important to develop a certain feeling for this so that we learn to translate the signals from outside into creative ideas. We can achieve this by consciously focusing on illustrative factors. For example, put together a still-life based on abstract features such as colour, shape or structure. Look for the most striking pictorial elements in a landscape, a photograph or a painting. Study a number of round shapes and discover the differences. An apple has a different shape, structure and colour from an orange, an egg or a tennis ball. Take a look at the pattern of branches of a bare tree and translate this into a dynamic play of lines. Maybe use the negative space as a positive shape for an abstract composition. You can read an aerial photograph of a landscape as a particular plane division. Ripples of water may be the inspiration for a composition with free, rhythmical shapes. Basically, the subjects for painting are there for the asking if you can 'see' reality as abstract.

A

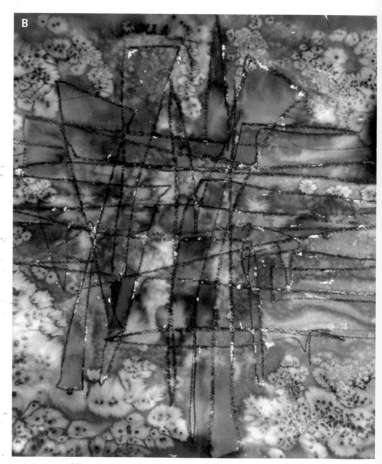

B

■ A, B, C and D Seeing reality as abstract

If we work constantly from our imagination we run the danger of one-sidedness rearing its head. Having a good look around you can help you out of that impasse.

Figure A is a photograph of organic shapes, which could be the inspiration for a textural study as in Figure B.

Figure B is an experiment with watercolour paint and salt. The rhythmic lines were placed over it later.

Figure C is an aerial photograph, the line play of drainage canals and coastline of which ultimately became the basis for the study in Figure D.

Figure D is a study in chalk and watercolour based on the photograph in Figure C.

That is how easy it is to get going again and to go in search of alternatives and variations. The greater our sensitivity to discovering abstractions from reality, the greater are our options.

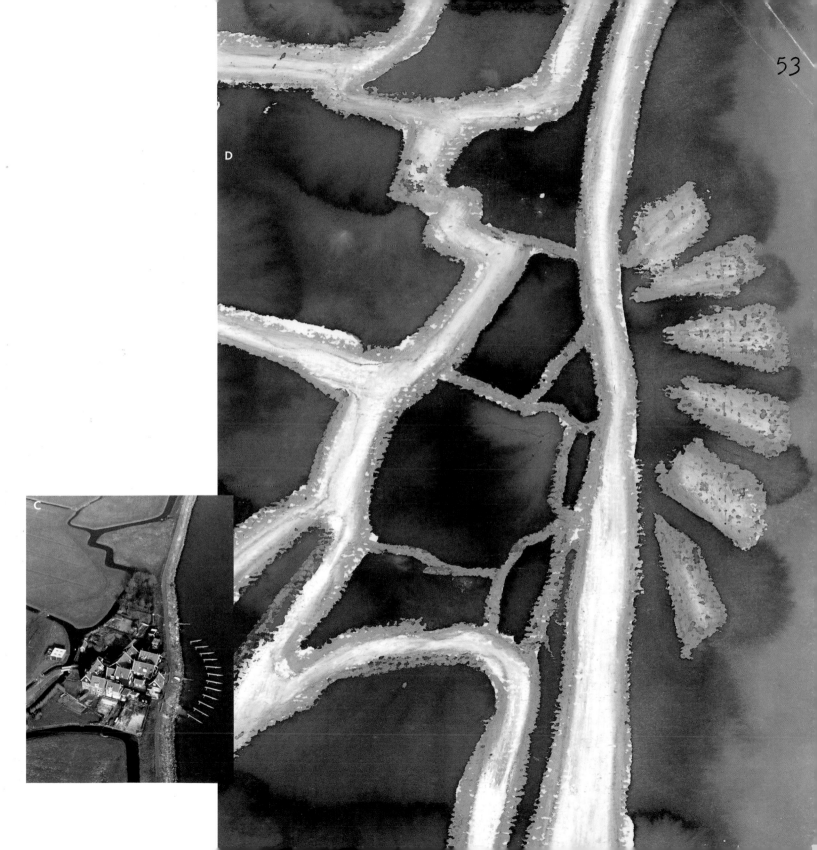

C

D

The qualities of shape

If we examine the various features and qualities of the element of shape or plane more closely, we create a new, extra source of study options. These are some of the opposites we can concentrate on:

– open and closed shapes
– flat and flexible shapes (two- and three-dimensional)
– static and dynamic shapes
– small and large shapes, narrow or wide shapes
– light and dark shapes, with much or little contrast
– unity or multicoloured shapes
– shapes with smooth or textured surfaces
– shapes with or without contour
– separate or overlapping shapes
– uniform or variable shapes
– transparent or opaque shapes.

To produce shapes we use the other primary elements. The nature of the shape, and its position and size, determine whether it has any influence on the secondary pictorial elements.

Study tip

• Whenever you make a study with one of the above-mentioned shape opposites as your starting point, you already have a series of tasks to start you off. Add to the series with your own inventions.
• Search extensively for concrete abstract shapes and make a separate study with each.

Shape technique

How and with what resources do we apply the element of shape? Too often we confine ourselves to giving contour and colour with pencil, pen, brush and paint, so I would like to draw your attention to the huge arsenal of technical options. For instance:

– printing and stamping technique
– pouring and dripping techniques
– dry- or wet-on-wet flow techniques
– textural and knife techniques
– collage technique with torn or found shapes
– stencil and cut-away techniques
– roller and sponge techniques
– scouring and scraping techniques
– contour and tapering technique
– line and scratch techniques.

Study tip

• Make a separate study with each of the techniques named. Try as far as possible to discover what effect can be achieved with them and look for variations and combinations. If you approach this seriously, you can easily spend weeks playing with shape and technique. Do not forget to keep your experiments and to write down how they were produced. The ultimate aim is for you to use them in your work.

■ A, B and C Playing with shape and technique

Three examples showing work done with different techniques.
Figure A is an example of texture, brush and drip technique.
Figure B began with a collage technique. Painting over it has caused the shapes of the torn pieces of paper to merge, creating the effect of slight texture. Use has also been made here of spray technique to indicate the contour line of the shapes.
Figure C shows shapes created by the print technique. For this, leaves were first covered in paint and then pressed on to the ground.

Size

The primary pictorial element of size can be applied to the dimensions of the support material. You can, for instance, choose a large or a small picture plane, narrow or wide, round or possibly triangular, horizontal or vertical. As a pure pictorial element, however, this refers to the size of the shapes placed on the picture plane – the scale on which the things are depicted. You can, for example, reproduce your subject as very small or as full image. You can also greatly enlarge part of it or reduce it to a microscopic detail. With size, we are also thinking about proportion and mutual relationships, such as the size of the head compared with the body, or a tree compared with a gate. The more we deviate from reality, the stronger is the abstracting effect and the greater the visual impact. If you are working completely in the abstract you can make the choice yourself. The main thing then is to make sure you have plenty of variation in format.

Size in relation to the other pictorial elements

Size and shape act as a double unit and influence the secondary elements. Elements such as depth and dimension, in particular, can be reinforced by reducing or enlarging the size. Variation, balance, pattern, rhythm and contrast can also be produced based on size.
The various shape and size alternatives are, however, still not applied nearly enough and therefore deserve our extra attention. Experimenting specifically with shape and size can help in this.

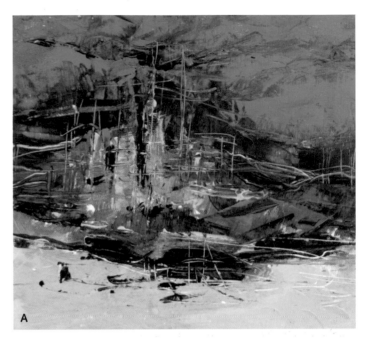

■ A Study in acrylic
The shapes have been applied here with the knife technique. Because there is a great deal of space around the main shapes, it looks as if the shapes are small in size. The size of the central shapes is small compared with the size of the large blue and yellow planes. Because of the technique, the shapes are open, irregular and textured.

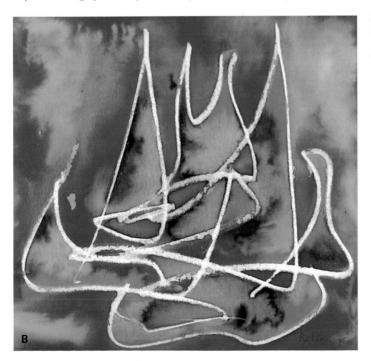

■ B Study in watercolour
The shapes here are starkly delineated by the contour technique used. Because this work was done with watercolour paint, there is also a flow and masking-out technique involved. The size of the shapes comes over as larger here, because there is little remaining free space. Moreover, the small blue planes between the larger green ones provide variation in the size of the shapes.

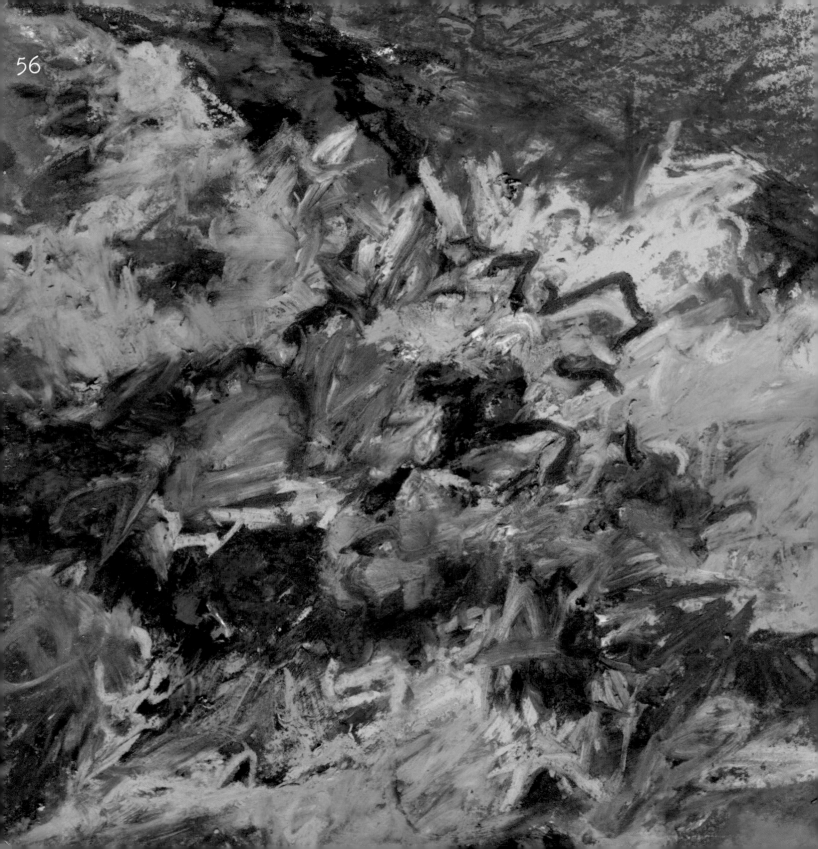

Colour

The pictorial element of colour is a real winner, a source of inspiration and expression we cannot do without as painters. Particularly in abstract work, the element of colour is the main constituent nine times out of ten.

However, colour is more than a superficial observation registered by the eye, since receiving colour signals triggers the creation of a special kind of communication in which our emotions play a major role. Colour does something to us. Because we instinctively accept and value certain colours and reject and dismiss other colours, it is often our feeling for colour that determines whether a painting affects us or not. For a painter, colour is, as it were, the messenger of a certain emotion, mood, atmosphere, aim or involvement. Colour speaks, tells our story, seeks contact with the onlooker and gives atmosphere and character to our work.

The impact of colour is therefore far wider than seeing colour planes and shapes. It is important to develop our feeling for colour in order to make full use of the options of this expressive pictorial element.

In search of individuality and expression

Or, to put it another way, from colouring to colour expression. What do we do with colour? The colours that have been put together for us in the factory are just the beginning of our voyage towards discovery of our own, expressive use of colour. In practice, I sometimes see paintings that contain nothing more than the colours from the pot or tube, works that are therefore a good advertisement for the manufacturer's spectrum of colours.

I would like to encourage you to do something of your own with your colours and thus develop your own spectrum of colours. I will help you to get started by listing a number of colour aspects and linking suitable experiments to them. You can then get going straightaway and try out your own feeling for colour.

Primary colours are red, yellow and blue. But not all reds are the same. Depending on the pigments and/or colouring agents used, there are sometimes great variations in the colours red, yellow and blue, each with its own character and resulting mix.

Get to know your individual colours by working in one colour in different techniques. Use the colour smooth or textured, as a paste or in aqueous form. Possibly add some black or white or another pigment of the same colour. Discover your own favourite colours. Take time to investigate each colour separately.

Secondary colours are green, purple and orange. You can buy them in a pot, but making them yourself is more exciting, especially when we discover that red and blue do not make purple – because here too the resulting mix depends on the kinds of red, yellow and blue we use. Make a series of greens. How many different orange tints can you make, and what sort of red or blue do you need to make purple? Make your own colour chart.

Tertiary colours are a mixture of primary and secondary colours. As soon as we mix the three primary colours together, we run the risk of producing sludge, but with the right pigments and the right proportions we can make beautiful neutral greys and browns. Try it.

Non-colours are black and white. Black from the pot is easiest, but rather boring and dull; we can make black more vivid by mixing it ourselves. For this, use complementary colours with a high pigment value. Make a painting in black, grey and white, and try to achieve differences in tone and contrast.

■ Playing with colour and materials
This was literally a game with oil pastels. I had bought a new box of pastels and was straining at the leash to test out the colours. This method is also handy for experimenting with your chalk technique. The shapes have developed on the basis of scratch technique, which means that texture and spontaneity dominate.

Opaque colours are covering colours. They cover the underlying layers. Some brands say on the pot or tube whether the paint is opaque or transparent. It is always sensible to test your colours for this, and to find out the effect of an opaque layer. Opaque paint can also be used to paint out parts of your work that you no longer wish to keep in.

Transparent colours are necessary for the glazing technique, by which we can achieve colour depth, harmony and unity. Try a few layers of aqueous glaze on top of one another. If we use the colour as a paste it covers the ground. As soon as the paint is mixed with opaque colours the paint loses transparency. Add a bit of white to a transparent colour to see this effect.

Analogue colours are colours that are adjacent to each other, e.g. red, reddish orange, orange. They intensify aspects such as harmony, unity and calm. Working with analogue colours requires a limited palette, but often gives us, with just slightly nuanced differences, a wealth of colour variation. Because all the tints contain a common colour, this kind of colour usage is very atmospheric.

Monochrome colours are variations within a colour family. We recognise the red, blue, yellow, orange, green and purple families. They give unity and harmony. Try painting with various blue colours and look for variations and combinations. Possibly add black and white or a little of the next closest colour. Consider differences in tone and contrast to give the work power.

Complementary colours are supplementary colours. A complementary colour is a mixture of the remaining primaries. Therefore green (yellow + blue) is complementary to red. Purple (red + blue) is complementary to yellow, and orange (red + yellow) is complementary to blue. Complementary colours intensify or dilute one another. If we place pure complementary colours side by side in narrow lines, the colours will vibrate, creating turmoil, movement and dynamism. Complementary planes side by side make the colours more intense. A red plane surrounded by green makes the colours, as it were, clash and shout. However, if we apply the complementary colours transparently, by glazing on top of one another or mixing them together, they actually dilute one another. The power of the colour then decreases and makes the colours more neutral and less striking. Use of the complementary function is a powerful means of achieving colour intensity, contrast and variation. Therefore consciously try to take advantage of it.

■ Acrylic on canvas 80 × 80cm (31½ × 31½in)
A detail from a painting completely dominated by the monochrome warm red. Giving it a few accents with black and adding yellow and white creates variation in tone and colour.

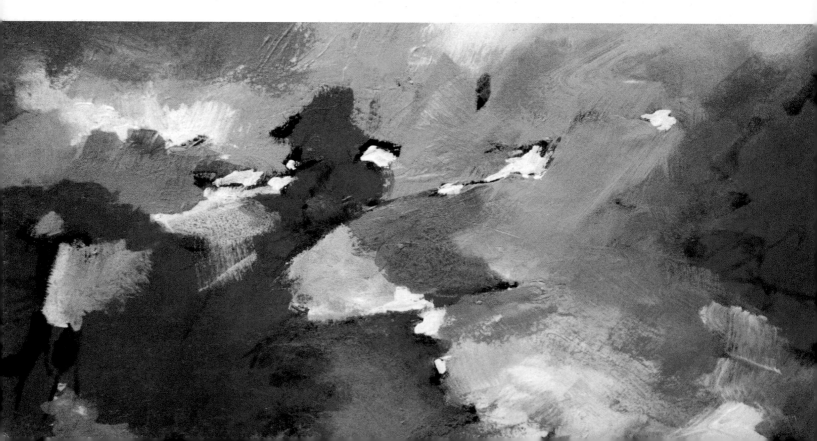

The **tone value of a colour** is its strength from light to dark. By lightening a colour with white or making it darker with black, variation in tone can produce the pictorial element contrast. For preference, try to make your colours lighter or darker with a little of another colour; this often produces surprising variations. Colours also each possess their own tone value or colour value. For instance, yellow seems lighter than red. Put all your colours in order of tone and try to mix the lightest and darkest version of each. Making tone ladders is a really good exercise.

The colour temperature, or the emotional value, of a colour can be seen in warm and cool colours. They ultimately determine the atmosphere of the work. Almost every colour has what is known as a cool and a warm variant. The warm variant over or next to a cool colour, and vice versa, can play a part in creating harmony and variation. Find out what warm and cool tints you have.

The spatial effect of colour Cool colours have a tendency to move away from us. Warm colours come towards us. Therefore, if we want to achieve depth and dimension, we must take this into account by having, for example, a warm red foreground and a cool blue background. If we are working abstractly we would be able to do just the opposite to give foreground and background the same status. Try both variants to find out the difference.

Colour tints are the different types of a colour based on the different pigments and/or colouring agents. If you compose a palette with two different colours of red, blue or yellow, your possibilities for variation are greatly increased. Moreover, a red plane, for example, becomes many times more interesting if a different red is worked into it or over it. So go ahead and do it: red in red, blue in blue, etc.

Colour intensity is the brightness, flatness or dullness of a colour. The pure tint is bright. By mixing it with other colours the intensity is diluted. Mixing with white makes the colours more matt, while mixing with black makes the colours duller and more neutral. Grey next to a colour makes colours sing. Black next to a colour makes the colour plane brighter, lighter and bigger. White next to a colour makes the colour plane duller, darker and smaller. Make a study with bright colours and frame the shapes with black, white or grey to judge the effect for yourself.

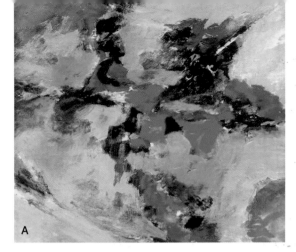

A

■ **A Colour study**
The complementary colours of red and green have been used here, giving a strong colour contrast that allows a focal point to develop.

■ **B Acrylic on canvas 80 × 80 cm (31½ × 31½in)**
A painting based on the cool analogue colours of blue, green and yellow. In colour usage of this kind, it is important that the pure tints remain present as well as the mixes. To further intensify variation and contrast, use has been made of two blue colours with different strengths of tone.

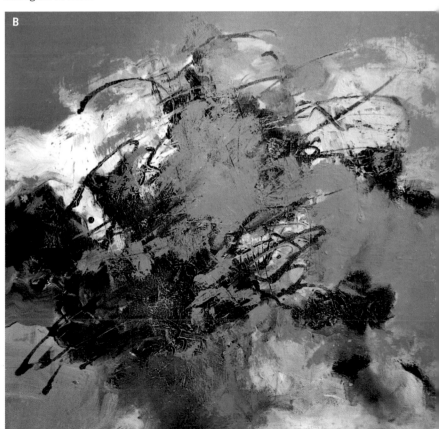

B

Colour depth arises when we paint colours in layers on top of one another. Therefore make regular use of underpaintings and glazed transparent overpaintings. Use the softening technique to allow underlying layers to shine through. Glazed layers and broken colours greatly advance colour harmony and unity.

Colour domination is achieved by working with an analogue or monochrome palette, for example, or by painting large, dominant colour fields. Even a much smaller strong colour plane dominates if the other colours are weak or neutral.

Colour equilibrium and balance. If a colour dominates, the eye automatically looks for the complementary colour to produce balance. The warm colour looks for a cold colour as a balance. Colour balance can also be achieved by making the same colour or tint recur elsewhere in the work.

Colour harmony and unity can be achieved by using analogue and monochrome colours. The use of underpainting or transparent overpainting and broken or repeated colours also promote colour unity.

Colour contrast gives our work power and emphasis. We can achieve this by using complementary colours. Differences in tone value, the difference between warm and cold colours, smooth and textured colour planes, pure and diluted colours, opaque and transparent also provide contrast.

The emotional value of colour is to do with the mood or atmosphere that it evokes. Especially with abstract work, the choice of colour is strongly linked to personal emotion and sensitivity.

Good use of colour

– **The essence of good use of colour lies in variation, tone value, intensity and contrast.** Without these facets, our work lacks power and becomes flat and meaningless.
– **First of all seek out your own spectrum of colours.** We recognise the work of a painter not only by the style, but particularly by the entirely individual palette of colours.
– **Colour mixing.** Make sure your experience with the various mixing techniques is up to date and does not remain confined to the familiar 'stirring of colours' on the palette.
– **Colour test.** After all that has gone before it seems unnecessary to say it, but I would advise you always to do a colour test first so as to prevent unpleasant surprises during your work.

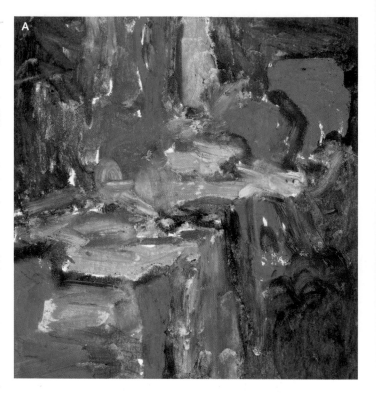

■ A and B Colour studies
If we place the colours pure and unmixed side by side, there is colour intensity and brightness. As soon as we bring the colours into contact with one another, interesting colour variations can arise from mixing. These so-called broken colours reduce intensity but reinforce colour harmony, unity and cohesion based on colour.

Study tip

• Twenty different colour aspects have been described for this. That means the same number of study exercises for investigating colour. Carry out the practice tips described, and for each aspect devise new assignments for yourself. If, in addition, you vary them by continually using different colour combinations, you easily arrive at fifty different colour experiments.

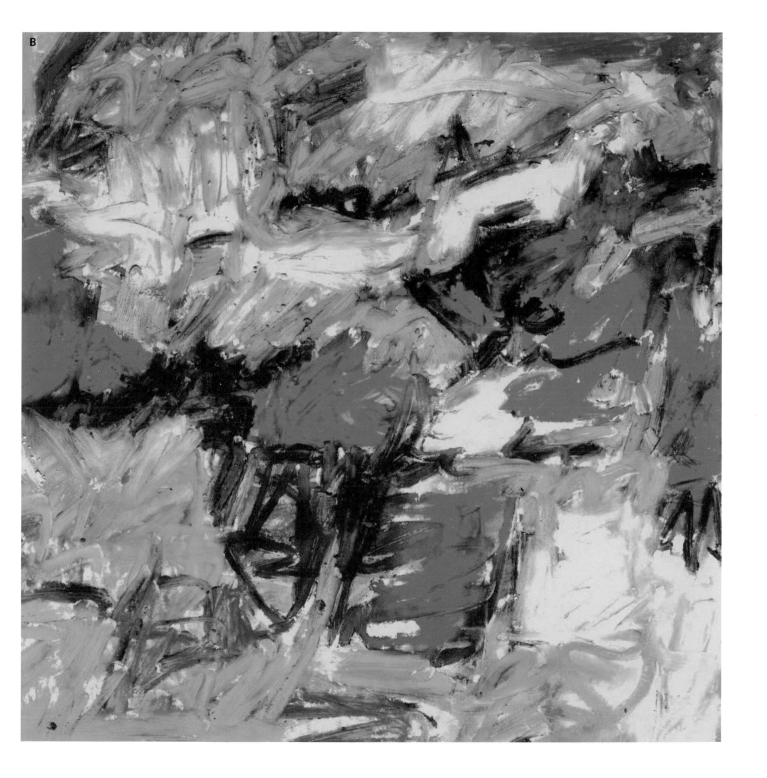

The pictorial element 'colour' as an autonomous subject

Colour alone is quite exciting enough to inspire a work of painting. If we learn to 'see' colour in an abstract way, therefore, without the significance of the object that has this colour, objects for painting are there for the asking. How about a field of sunflowers or a sunset? Once you see it only as a yellow or red colour plane, you have enough to go on to start a painting. So learn to observe abstractly.

Colour and the other pictorial elements

Alongside the primary elements of line and shape, colour is a forceful picture-defining element with great power of expression. Moreover, colour is very important for achieving various secondary pictorial elements. As abstract painters we are almost totally reliant on intuitive, instinctive usage of colour, simply because there is no colour example to hand. We must therefore do all we can to develop our own feeling for colour into a source of expression. Let your colours do the work, let them speak.

■ Acrylic on canvas 100 × 120cm (39¼ × 47¼in)

Figures A to D show the construction and working sequence of the painting below. To start a painting it is sufficient to use the elements of line, shape and colour.

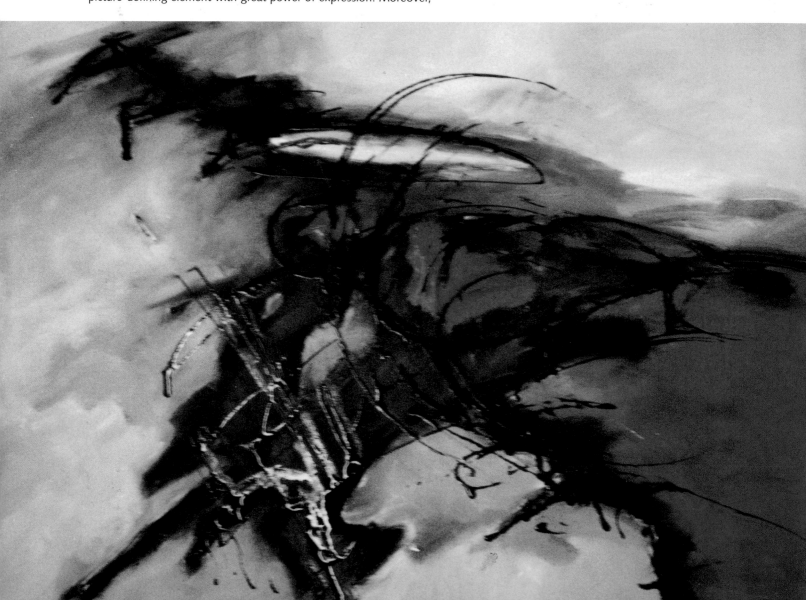

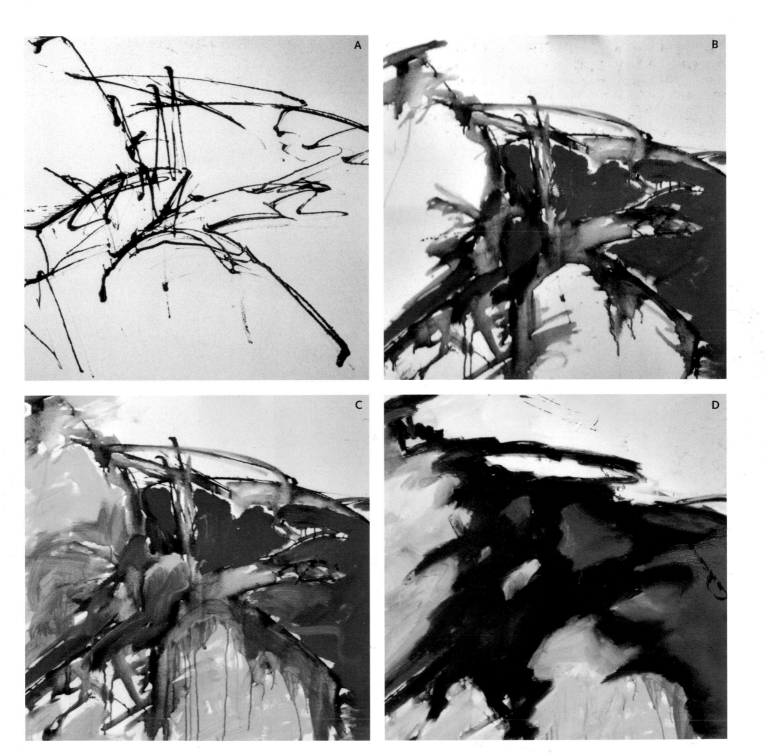

Tone or value

Strength and weakness of tone are decisive for the power of planes, lines or shapes, and greatly influence the character of the work. The pictorial element of tone is greatly underestimated in practice. This results in flat, dull and literally monotonous work, with little expressive power.

The lack of tone intensity and, more particularly, of tone variation, is easily solved once we are aware of their necessity. Train yourself to use a tone scale of a minimum of three values in each work. That applies to both black and white and colour. Always be sure to check your work for the presence of light tones, medium tones and dark tones. Making tone studies can give us the necessary experience.

Tone and the other elements

Tone plays a part in balance, variation, gradation, unity, harmony, dominance, accent, contrast and opposition, as well as in indicating the focal point and points for particular attention. The element of tone also influences the atmosphere and the mood the work emanates. Tone varies from hard and impersonal to soft and sensitive. Tone accentuates the effect of light, whether sharp or diffuse. A pale field will always give the effect of light and space compared with a dark field. Differences in tone enable us to distinguish shapes from one another and to observe them separately. This means we do not need a contour. Nuances of tone make our work more vivid. After colour, contrast of tone is our strongest means of producing the power of attraction.

Study tip

- Start by making a tone ladder of white, via various greys, to black.
- Make a tone ladder with each of your colours. You can vary the tone of your colours by using white and/or black, or by thinning the paint with water.
- Make a study in high key or low key, or in light or dark tone values.
- Try a study with a gentle progression from light to dark tone values.
- Make a tone study with strong contrast, in black and white and hard transitions.
- Repeat that study in colour.
- Investigate the tone value of the different colours. Is your red darker than your blue or not?
- Make a study in pencil or paint with two, three, four or five different tone values.

■ Acrylic on paper

A study in monochrome colours and dark tone values, this work was constructed entirely with a palette knife. You can build up wonderful effects and structures in this way. But you must be careful with a tool of this sort and make sure you apply enough variation, otherwise it becomes boring and monotonous. The composition has been constructed with equal balance between horizontal and vertical.

■ **A and B Acrylic on canvas 80 × 100cm (31½ × 39¼in)**
A work with strong tone variation and contrast. The two provide a harsher character and sharply defined shapes. If we reproduce this work in black and white (Figure B), we can see how dominant tone contrast can be.

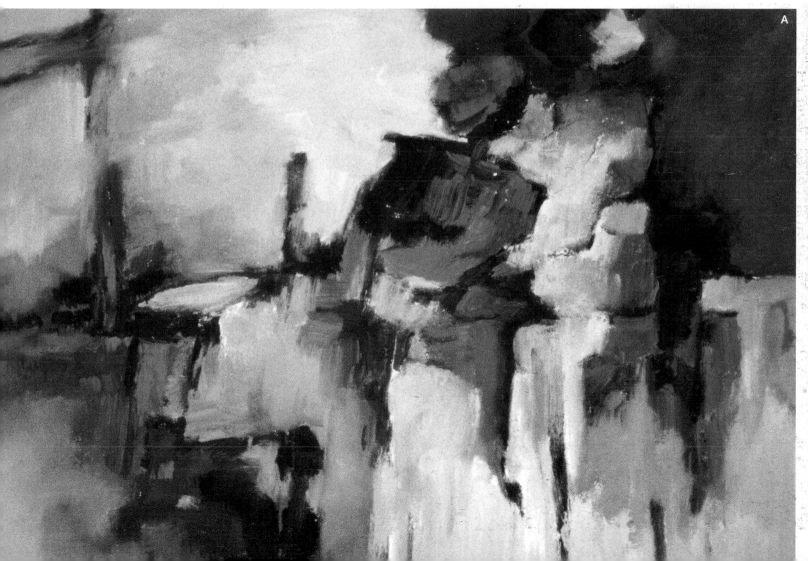

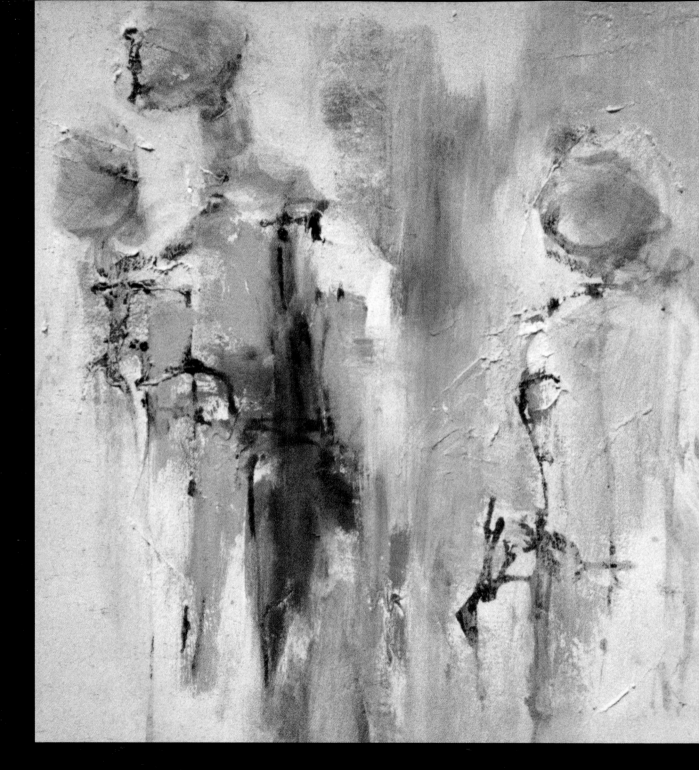

■ **Acrylic on canvas 40 × 50cm (15¾ × 19¾in)**
A painting in a pale tone intensity (high key) with little colour and a lot of white.

■ **Mixed technique on canvas 30 × 30cm (11¾ × 11¾ in)**
A work in darker tone values (low key). The work was constructed with a textured layer in relief thickness.

68

Texture

What is texture?

Briefly, it is the effects that disturb or break up the smooth surface of the painting. It is the varied layers with which we construct our work. It is everything we apply under, in and over our layer of paint, providing the surface with variation, unevenness, difference in height or roughness. Texture is therefore an artistic element that greatly defines the picture. Texture encourages the building up of layers. In this way it gives the impression that the painting has been thoroughly worked through, and not just literally, but also figuratively, it gains more depth. In this way, the painting gives an inkling of the method and the involvement of the artist.

Texture offers a great wealth of details and accents that are 'unfinished' and more or less indefinable, but which produce questions that we ourselves must find the answers to. Texture keeps us busy. Over and over again there is something to discover. Texture is a personal response to the material, and for this reason alone reinforces originality and individuality.

What texture has to offer us

– activates imagination, creativity and expressiveness
– gives us the impetus to experiment and discover
– encourages us to find our own pictorial language
– leads to unexpected, interesting and surprising effects
– ensures variation, contrast, accent and dynamism
– encourages us to paint layer over layer, creating depth and dimension
– gives us the impetus to simplify and abstract and move to a freer way of painting
– intensifies sensual perception and visual communication
– takes our painting to a higher plane of artistry
– makes boring parts active, vigorous, lively and stimulating
– intensifies the power of attraction of a work
– is a great source of direct inspiration.

If we are able to give something of all of that to our work only once, we are on the right road.

■ Textural study in mixed technique

From the beginning to the end, this study was simply a great experiment made with different materials. I begun with watercolour and pastel. To obtain more colour and to push back the white, I continued with acrylic and followed up with wax crayon. I finished with a partial glazing to reinforce unity and colour harmony.

Study tip

• Make a study in which textured planes alternate with untextured planes.
• Follow up with a completely textured study. Then use the same composition and colour for a completely smooth finish.

Foundation for free expression

You can, of course, also make good work without the pictorial element of texture. After all, we always have a choice about whether to use something or not. The result of your work will, in one way or another, be determined by whether your pictorial language contains sufficient variation, originality and artistry. If, in practice, we can see that our pictorial language is still insufficiently developed, the element of texture can really make a difference. Particularly if we follow the abstract road, texture ultimately proves to be one of our strongest tools. You could even say that texture and the element of colour together are the foundation for expressive abstract painting. However, texture was not learned at our mother's knee, as is the case with the element 'colour', and so we have to build up our feeling for texture from the beginning.

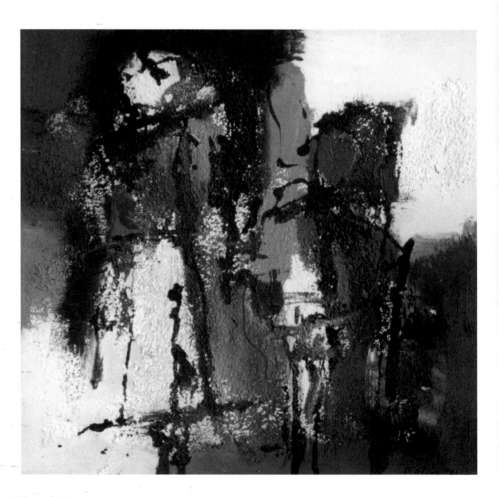

■ **Mixed technique on canvas 40 × 40cm (15¾ × 15¾in)**
A layer of rough textured paste was first applied randomly. After it had hardened, the picture was finished off with acrylic paint and ink.

Not a technical box of tricks

There is an enormous number of techniques, resources and materials to add texture to your work. Some of them are described in almost every book. Yet the best way to develop a real feeling for texture is by experimenting with it yourself using everything that comes to mind. However, if we apply texture without enough personal input and originality, we run the risk of using texture as a kind of technical box of tricks. A warning is definitely required here: excessive and unbalanced use of a particular texture causes the positive value of this picture-defining element to tend towards the negative side. Poor use of texture looks monotonous and has similarities with tricks that one has learned and clearly become stuck with through lack of variation. It is a sign of amateurism and a lack of insight into picture-defining elements. So, good textural usage originates solely in a self-developed feeling for such effects.

Study tip

- Texture is just about the greatest adventure you can set out on as a painter. Prepare all your materials and tools. Experiment based on how you can use the materials. Start splashing, pouring, blowing, scraping, stamping, stippling, scratching, brushing, and anything else you can think of.
- Look for materials that you can print and stamp with in order to build up a texture. Try a ball of paper, sponge, leaves, fork, foil, jute or cardboard.

■ Acrylic and stone fragments on MDF 60 × 60cm (23½ × 23½in)
Texture can be applied even to relief thickness. Here, thin, flat pieces of slate have been stuck to the ground with gesso. They formed the starting point for the composition. Colour was added later with acrylic paint.

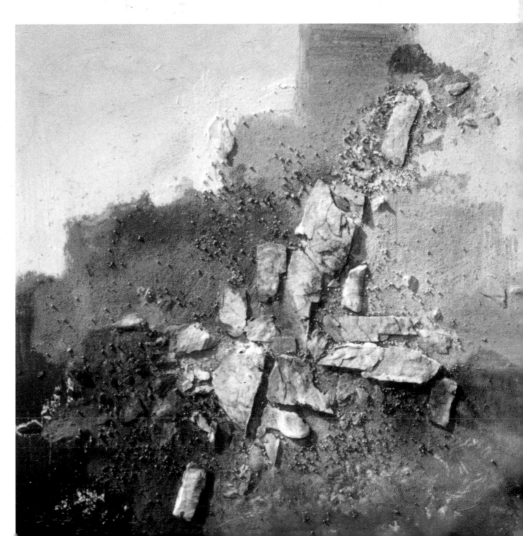

Texture: how, what, where?

Generally speaking, we can introduce texture at three stages during the painting process: beforehand on the support material; during painting; or afterwards, over the paint layer. It is obvious that in all cases the possibilities and effects also depend on the characteristics of the material we are using.

Texture on the support material

We can give the support material a certain texture even before we start to paint our actual subject. Some grounds already have this. For instance, linen looks different from a sheet of MDF, and paper is available with rough or smooth surfaces.

To give the support material some sort of excitement we can undertake the following actions:

– Stick paper, cardboard or a textile, for example, to the support material.
– Cover the support material with an undercoat of textured paste or gesso, to which we add fillers such as sand, sawdust or plaster of Paris. Depending on the filler, we can even go as far as the thickness of relief.
– Treat the support material with a layer of paint or gesso, in which, before it dries, patterns, lines and shapes are applied by scratching, scraping and pressing. In this way, we give the support material in advance a certain unevenness, which, once hardened, will have an effect on the rest of the painting process.

Texture in the paint layer

Once we start painting, we can add more texture. This means we perform actions while the paint is still wet, such as:

– adding water, salt, sand, glue or bleach, for example
– varied working with brush, knife, roller, sponge or palette knife
– pressing, scratching and making uneven areas in the paint with foil, paper, sponge, comb, plastic, stamps, etc.

Texture on top of the work

Finally, we can make our work more vivid by applying texture on top of the now dry painting with anything that is effective, such as making prints with stamps, a ball of paper, textiles, corrugated cardboard or bubble-wrap.

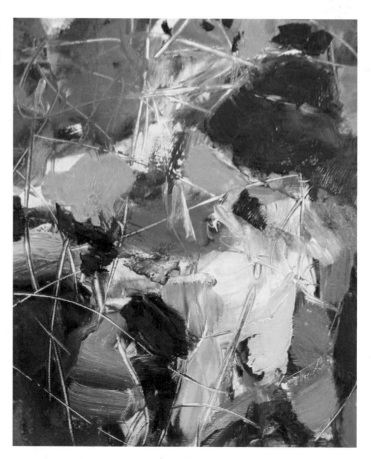

■ Textural study

We do not always need to add something to the paint to indicate texture. Texture can also be created by scratching the paint or letting the brushstrokes be clearly seen, as in this study with acrylic.

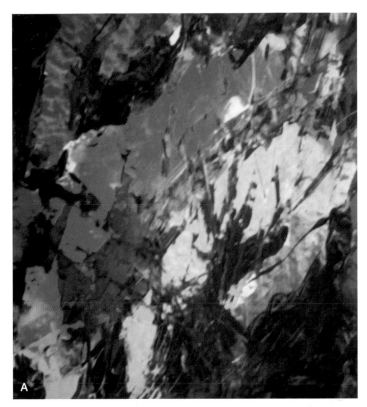

Voyage of discovery

In practice, we often see paintings foundering because the creative input remains confined to filling in colour planes or other kinds of one-track work. Texture can help to solve that problem. There is an enormous number of techniques that each provide a certain texture in different ways. These include impasto, frottage, sgraffito, sponge, roller, scraping and knife techniques, and have you ever tried the drip, wash, spray and scratch techniques or the printing, stamping and collage techniques? How did you find materials such as salt, bleach, plastic, sponge, glue, plaster of Paris and so on? You will, of course, also experiment with the many textural materials specially developed for painters, such as the different gel media and textured pastes. You can take it from me that it is a great adventure. It is here, in particular, that playing with technique and materials really comes into its own.

A The accent here was on forming texture with the knife technique.
B If we start experimenting with aqueous paint, we can make our work more vivid using the drip and spatter technique.

Study tip

- Go and experiment extensively with these textural techniques. If you approach this seriously, you can spend months on it.
- Investigate the effect of the different fillers and media that specialist shops have to offer. Devise alternative fillers yourself, and examine their effects.

■ **Playing with...**
Effective studies can be made even with simple materials such as coloured pencils, pens and felt-tip pens. We can then concentrate fully on the secondary pictorial elements, as in these examples. Here the accent is on rhythm, repetition, pattern, harmony, unity, cohesion, balance, variation and dynamism.

10. Secondary pictorial elements

The secondary elements of movement, pattern, balance, unity, variation, dominance, contrast, dimension and space are produced with the aid of the primary elements

The secondary elements influence the composition, the power and strength of the work. The questions we need to ask ourselves are:
– which secondary elements should I use?
– how do I create unity in the whole?
– where does the emphasis lie?

This seems complicated, but consciously learning to deal with the secondary elements can help us to put things in some kind of order. In time, we will add all the pictorial elements to our arsenal of emotional aspects. We will then no longer use them consciously, but intuitively. For this, we first need to know what those elements imply and what we can do with them.

Movement or dynamics

Movement or dynamics indicates direction, animation, energy and action. Movement is, in fact, visual progress from one place to another. Movement helps to determine the route and speed with which the eye scans the painting. It leads the eye into, through or out of the painting. Here, too, conscious use of the element should be considered, so that you can direct the eye to where you want it to go. We can apply movement with the aid of line, shape, colour and texture in a particular direction. Horizontal, vertical and diagonal components play a role in this. If the accent is on horizontal trajectories, this gives a more peaceful appearance than if the accent is on the diagonal direction. Vertical accents emphasise stability. Diagonal is energetic. Alternating the various directions gives the composition suspense.

Repeats and rhythm also indicate movement because our eye follows the rhythm and hops from shape to shape. The element of colour can also effect movement, such as from light to dark, from bright to muted. If we place complementary colours rhythmically side by side, movement emerges from vibration.

You can also create an active picture with your technique. Your brushstrokes or line drawings might be short and aggressive, for instance, or long and wavy, angular or flowing, rhythmical or static. Decide in advance what dynamics fit in with your idea – a steady, peaceful picture or a vigorous, dynamic picture.

Pattern, rhythm and repetition

Pattern, rhythm and repetition point to shapes, lines and textures that appear more or less equally several times, thus forming rhythmical repeats. Rhythm and repetition may be irregular, but pattern is always a regular repeat. Pattern, rhythm and repetition accentuate movement and dynamics, but also unity and cohesion. They might dominate, but require tranquillity as the opposite pole. Above all, textures often consist of patterns or rhythmical accents. Even a short rhythmical brushstroke gives an impression of action. Various techniques, such as printing and stencilling, are very effective for suggesting rhythm and pattern. Furthermore, rhythmical movements activate spontaneity and a freer painting gesture.

Recognising and 'seeing' patterns and rhythms in reality is definitely to be recommended. We can draw many painting ideas and much inspiration from this. Just think of the rhythm of ripples of water, waves, branches or poles. The elements of pattern and rhythm are particularly interesting as the basis for a study exercise. There are painters who fill the entire picture plane with a repetitive pattern, solely on the basis of rhythm.

Study tip

• Fill a few sheets of paper with lines or spots in a rhythmic way. A rhythmic gesture is comparable to the beating of a rhythm.
• Look for something that you can stamp with, such as a cork, a block of wood or a piece of sponge, and create a repetitive pattern. Treat your paper beforehand with an underpainting or textured ground.

Equilibrium or balance

Equilibrium and balance lead to tranquillity and are related to various aspects. A composition usually requires a plane division in which there is a certain balance, so that the painting does not dip to one side. Symmetry is the absolute form of balance. It is less attractive as a plane division. It gives a rather static arrangement, with little space for the eye to move around. However, there are artists who actually see this as a challenge and therefore often start out from symmetry.

If we start from unequal shapes which, in addition, are also placed just off centre, we need to seek balance. A large heavy shape on the right requires several less heavy shapes on the left. The more shapes there are in the picture, the more complicated is the visual balance. Rules of painting once taught us that the main theme of our painting does not have to be placed exactly in the middle. We usually place our main motif slightly above, below, left or right of the centre, as geometrically stated in the golden section theory. In practice, we therefore usually choose asymmetry.

In combination with dynamics, movement and direction, we distinguish static balance and dynamic balance. Balance is not just a question of shape, but also relates to balance in tone, colour and texture. Repeats are essential to create balance.

Unity and harmony

Unity and harmony are by far the best means of bringing about order and cohesion in all the shapes, lines, colours and textures. This is not easy and it requires a great deal of experience to develop an intuitive feeling for unity. You need to have the feeling that everything is in place, nothing needs to be added and nothing needs to be taken away. Everything has been integrated and has its own individual function in the whole. Linking accents and repeats are important means of producing cohesion. Colour can also be a linking factor, if we glaze the entire work in one colour. It is the art of bringing diversity and unity together in such a way that it looks like a whole. We can develop a feeling for harmony if we are aware of the facets that can bring about unity.

Variation and gradation

Lack of variation is one of the most frequently occurring deficiencies and is particularly fatal in the abstract school. Variation and gradation remind us that a painting needs more than the same shapes, colours, accents and plane divisions over and over again. From time to time we have to force ourselves to develop new pictorial language to prevent monotony and lack of strength in our work. There is nothing more boring than a work where the same brushstroke or texture is used from beginning to end. The familiar getting stuck, not going further forward and coming to a standstill is largely due to a lack of variation. Therefore deliberately look for the unusual, unexpected and surprising. Play based on spontaneity and freedom is a wonderful means of extending our variation options.

Study tip

- Regularly put new colour mixes, tone accents, new application techniques, varied brushstrokes, new ways of plane division, etc. on your agenda.
- If you are stuck, set to work as follows. Analyse your work on the basis of the pictorial elements. Using these, determine the opposite and choose that as the starting point for your play. If you always paint with red and yellow, put those colours away for the time being. If you always paint with the brush in a vertical direction, vary it in all directions in the next study. If this does not release you sufficiently, study other people's work – it might inspire you to a different approach and help you overcome your own ideas blockage. At all costs avoid copying other people's work!

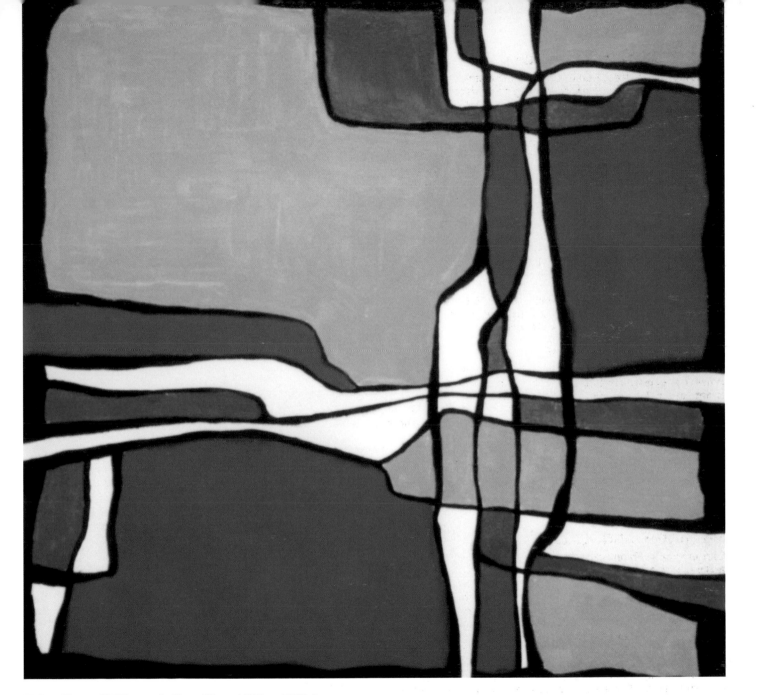

■ Acrylic on MDF panel 40 × 40cm (15¾ × 15¾in)
A carefully constructed composition, with a balanced division of colour and plane. The black contours intensify contrast and strength of colour. On a rectangular picture plane, horizontal and vertical components have equal value. The art is finding the balance between these two without it resulting in static symmetry. Creating a dynamic balance, as here, is a real challenge. Variation in shape and size provides the focal point for us. The lines and contours guide the eye and ensure cohesion and connection between the separate colour planes.

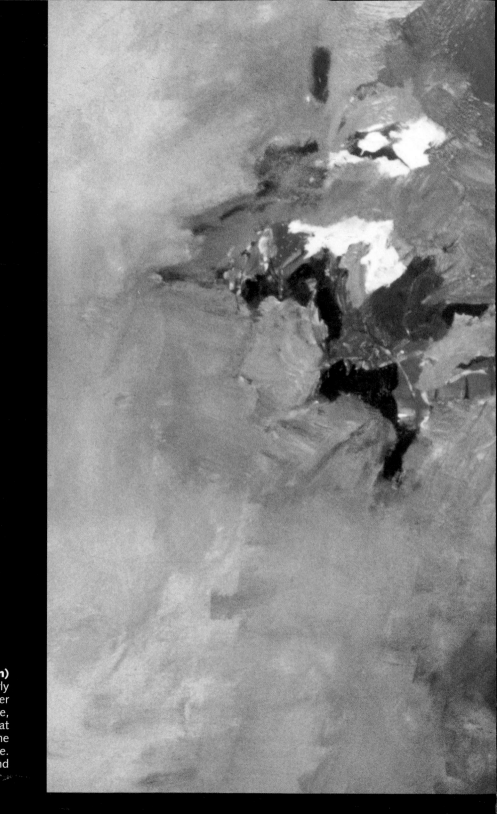

■ **Acrylic on canvas 100 × 120cm (39¼ × 47¼in)**
An expressive painting in muted colours. The fairly
large tranquil planes form a contrast with the smaller
accents in the centre. Variation in colour, tone, shape,
rhythm and the handling of the material ensure that
exciting things happen. We spend far more time
looking at a work if there is plenty for us to investigate.
A composition gains suspense and power if passive and
active parts alternate in it.

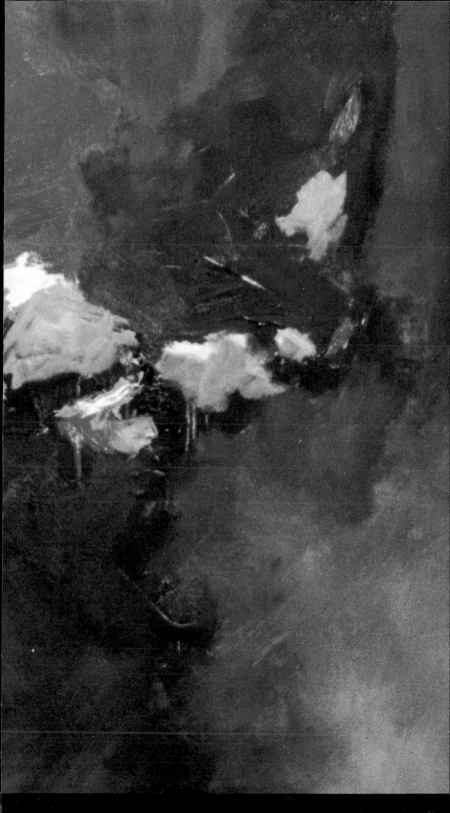

Dominance and accent

Dominance is of great influence on the power of a work to attract. It distinguishes the principal issue from subordinate issues. Dominance brings about the very first communication between picture and observer. It determines what the most important thing is, and allows it to dominate by means of colour, shape, line and texture. Movement, pattern, rhythm and dynamics can also play a strong role in attracting attention.

Dominance might be involved with the focal point in a composition, but might also relate to the whole. For instance, there is also dominance if a large, tranquil area that attracts little attention is executed in a dominant colour. Dominance is easily guided by mood and feeling: for instance, am I in a red mood today or rather blue? Am I in a raging temper or calmness personified? Do I want soft, flowing colour fields or hard, contrasting accents?

Dominance therefore always has an influence on the atmosphere and the aim we give to the work. Dominance, of course, implies that other parts are therefore given less attention, but are necessary to complete the whole. Dominance is a means to help you choose what you want to emphasise. If you have a painting with too many points of attention, dominance can bring order and tranquillity.

Contrast and opposites

Contrast is excitement, attention, dynamics, action and suspense. Any painting that is flat or monotonous can be pepped up with contrast. Contrast can come about in all kinds of ways. Contrast is the difference between saying nothing and the power of speech. Too much contrast, however, leads to turmoil.

We need contrast to indicate our focal point. Contrast is based on a particular pair of opposites, such as action versus calmness, large beside small, a lot with a little, light and dark. Contrast arises with the aid of the primary elements. Contrast wakes us up with a jolt, demands attention and cannot be evaded. We step into a painting, move away from it and return to it.

Study tip

• Make a study with each of the primary pictorial elements of line, shape, format, colour, tone and texture, with the accent on contrast.

■ **Acrylic on canvas 80 × 80cm (31½ × 31½in)**
This composition has a clear focal point and stark alternation between the active and passive parts. It does not use a traditional plane division, but one of the modern variants. There is a high, horizontal active part, with a fairly large passive part underneath, and, for balance, a small part at the top. The active part is created by the contrasts in colour, shape, size and texture between it and the larger, still parts elsewhere. The active part in the painting gives us the focal point, from where we can further examine the whole. Colour repeats and textural accents lead our eye to the other parts of the painting and ensure correlation, cohesion and unity.

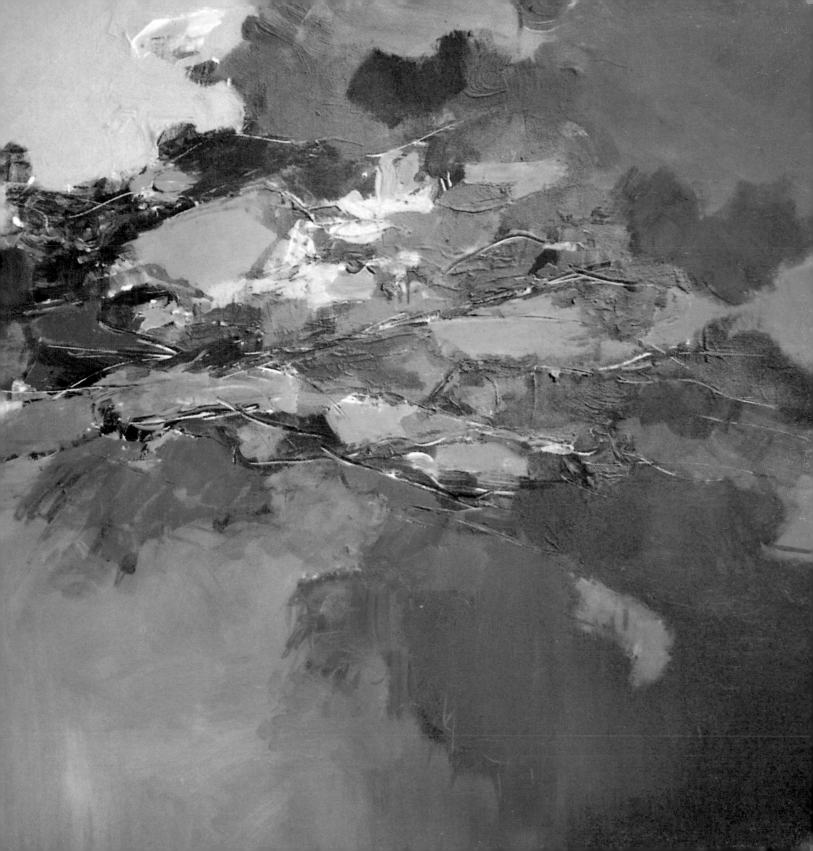

Dimension or depth
(three–dimensional)

Dimension has to do with depth, or whether our work looks two-dimensional or three-dimensional. Is it flat or does it seem to be more? It will be clear that we must deal with this very consciously and decide whether we want depth or not.

There are many ways to create depth:
- The rules of geometric line perspective: parallel lines that run towards the horizon seem to meet there, etc.
- Size and shape perspective: shapes at the front are larger than shapes or objects further away.
- Foreground versus background emerges if our composition contains an open space round the subject: as soon as our subject touches or goes beyond the sides, the effect of foreground and background disappears.
- Colour perspective arises from colour power in the foreground versus muted colours in the background, or warm colours in the foreground and cool, receding colours in the background.
- Atmospheric perspective: detailed shapes and textures demand our attention and spring into the foreground; smooth, vague parts denote background.
- Overlaps: shapes placed behind or on top of one another show that one is closer than the other, thus suggesting some depth.
- Light and shade lead to spatial design and accentuate the three-dimensionality of an object.
- When texture approaches the thickness of relief, depth emerges literally and tangibly as a third dimension.

It goes without saying that if we do not want depth, we must avoid the above effects. In general, in abstract work we do try as far as possible to prevent depth related to reproducing reality, although we do apply effects of depth that arise due to texture.

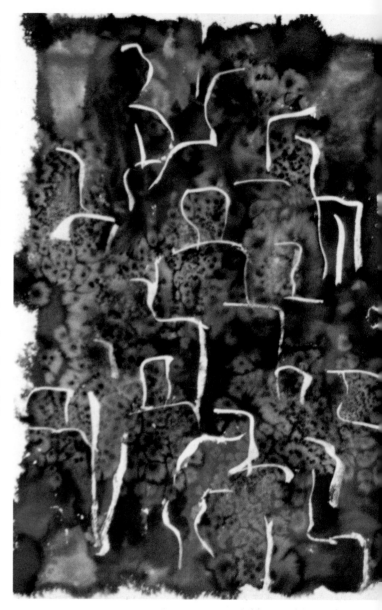

■ Mixed technique on paper 50 × 65cm (19¾ × 25½in)
This was an extensive experiment. Watercolour paint and salt provide texture, and together they suggest a certain amount of depth. The lines, applied with masking film in what we call shade contour, seem to overlap. This always gives an effect of depth, because one shape is therefore placed in front of or behind the other. The shapes have been applied so as to fill the picture, which means there is no remaining space. Furthermore, it is not clear where the shapes end and the negative space might be. The two latter aspects reduce the three-dimensional effect and make the work flatter and more abstract.

Space and plane division (two-dimensional)

A work can give us the impression of space depending on the way we have divided up the picture plane. Smaller shapes surrounded by a large, empty, open field suggest a lot of space, tranquillity and stillness. Objects that fill the picture give little information about any further space that might be present. A close-up makes us dive into the picture, without paying any attention to the space around it. Lines that lead us to the edge of the picture plane suggest that our subject continues in the space outside. Closed shapes and areas are shut off from the further space, so there is an inside and an outside. Open shapes absorb the space and make the space part of the whole.

Space has a function in the ultimate plane division. A composition with separate shapes gives each shape its own individual space, but loses cohesion. Shapes that touch or overlap close off and dispel the effect of space, and demand tranquillity and space elsewhere in the picture to counter this.

Spatial effect depends on the way we place the shapes on the picture plane, with a lot or only a little remaining space. Space can further be indicated as positive and negative space, as subject versus remaining space, or emptiness. Playing with composition and plane division intensifies our feeling for space and the way that space is divided up.

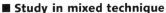

■ Study in mixed technique

There is space remaining around the self-contained main shape. If we give that open negative space a lighter tone intensity it gives a feeling of space and depth. The stronger the colours of the actual 'subject', or the positive shape, the more it comes towards us, which intensifies the feeling of depth and space.

Study tip

• Make a composition with free remaining space round it, and then make one without any free space. Finish the composition with light, receding colours for the remaining space, and strong, imposing colours for the positive shapes. After that do it again the opposite way round. In other words, dark, imposing colours for the remaining space, and light, cool, receding colours for the shapes. You will see that with the latter combination the effect of depth disappears.

11. Composition

Composition is the organisation and arrangement of the pictorial elements that together constitute our pictorial language.

Composition is the framework, the starting point, for our painting process. Creating a composition can vary from being direct and extremely spontaneous, to carefully constructed and well thought out. Composition should always be part of our preparation stage. It is useful to know how specific aspects of composition play their parts.

- What size is the support material: large, small, square, horizontal, vertical or narrow?
- What is the proportion and balance like in the shape structure and the plane division?
- What is our view on the picture we want to present? Is it a panoramic view, with a lot of remaining space and background, or does it fill the picture in close-up with scarcely any remaining space? Are we looking at our subject from underneath, on top or in profile? Are we choosing detail or cut-out? If there is a horizon, do we place it half way up, very low or very high?
- Where do we place the point for attention, the focal point?
- What are the main features of the composition, the main direction and the direction of the introductory and possibly executing lines?
- Where do we place our active parts and where is there calm?

Dynamic balance

A good composition has a certain suspense and balance based on opposites and contrast. Suspense is the feeling that something is happening, that there is a certain amount of action. Factors such as direction, dynamics, dominance and emphasis play a part in this, and we now know that our primary and secondary pictorial elements can provide it. For practical application, it is definitely useful to pay conscious attention to:

- **focal point**
- **active and passive**
- **plane division**
- **foreground and background.**

■ **Acrylic on canvas 100 × 120cm (39¼ × 47¼in)**

The plane division is given extra suspense if we alternate active parts with passive parts. There is then a dynamic balance between movement and stillness. This painting almost looks as if it has been split in two. On the right there is a great deal of dynamism and alternating shapes, which serve to attract the attention and act as a focal point, and on the left there is a fairly large still part. Generally speaking, there is nothing there that demands our attention, but the colour red is so strong that it neutralises the dichotomy. The yellow shapes that penetrate into the red and the tiny dab of repeated black on the left draw the red towards the centre. They provide cohesion and balance, supported by the calm of the black area at the top on the right. In this composition, the accent is therefore on a central vertical active part with two passive still parts in strong tone values next to it.

Focal point

The focal point is the part of our theme that we want to give full attention to and thus want to emphasise as important in our picture. We can give this part extra accentuation by the way in which we use format, colour, tone, line or shape. That means that we give less to other parts.

The focal point is not an image that stands in isolation. It is accompanied by connections and secondary focal points in such a way that cohesion and unity make it into a whole. Introductory lines play a crucial role in this. These are purely suggestive lines that lead our eye to the focal point and the other accents in our picture. These lines are absolutely essential to a focal point. Without these lines our eye lands abruptly at the strongest point and stays there. The whole then remains outside the picture. Our focal point is, in fact, a combination of point for attention and lines leading in or out: the signpost for our eye, the direction we follow visually.

You do not have to see these lines literally as a stripe. Successive accents in tone, texture, pattern, rhythm, colour and shape can also lead our eye along a certain route.

In general we do not place our point for attention centrally, but slightly off-centre of the picture plane. If, in so doing, we keep to never placing our main accent on the horizontal, vertical or diagonal centre line, we are doing well.

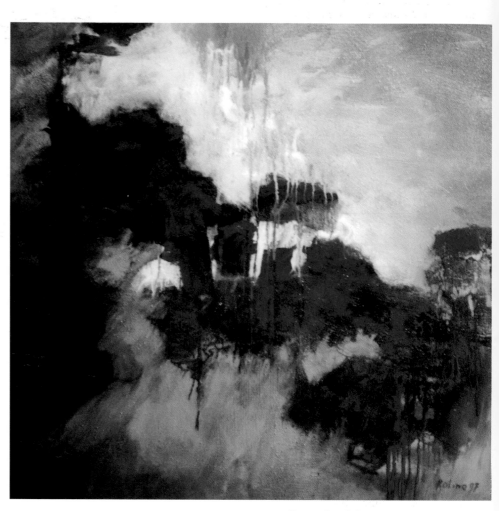

Study tip

- Make four compositions with the focal point in a different place each time. At the same time think primarily about linking factors that lead our eye to or away from it. The focal point is therefore not something that stands in isolation.
- Make four different compositions clearly alternating between active and passive parts.

■ **Acrylic on board 80 x 80cm (31½ x 31½in)**
This composition is the result of a diagonal plane division, with active parts and passive parts. The textural effects, made by the drip technique, that run across the picture provide action and vitality. They also act as focal point and accents to guide the eye. Around the active parts are calmer colour fields, in which there is less detail. The great colour contrast between dark blue and virtually white gives a strong effect of depth. The blue then comes to the fore. This is a work in which we encounter practically the entire arsenal of pictorial elements.

Active and passive

A composition gains power and suspense if there is a certain amount of alternating between the active and passive parts.

By active parts, we mean the parts where something happens, to which the eye is drawn; the spot where we step into the painting and where contact with the observer begins. It may be the focal point, the lines leading in and out, or secondary focal points. Action can be indicated by a great amount of alternating, contrast and variation in colour, tone, texture and dynamics. Technique and materials play a role in this.

By passive parts, we mean the items that give an aura of calm, parts that attract our attention less and in doing so emphasise the active part(s). They calmly give our eye the space to scan the painting further. Horizontal, vertical and diagonal accents have a linking function between the active and passive parts. It is precisely this alternating that is a strongly image-defining means, with which we are still not sufficiently consciously involved. Playing with the plane division and models of plane division can help us with this.

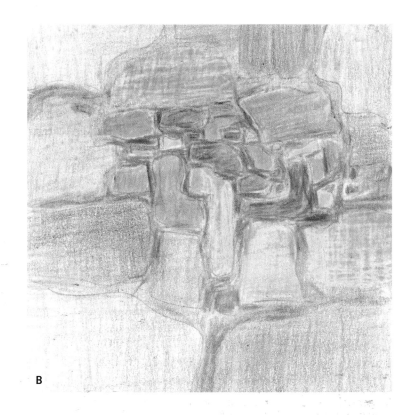

B

Plane division

The dividing up of our picture plane is the starting point for our composition.

Using the location of the focal point and the main direction in which the shapes are arranged, we can indicate a number of traditional ways of plane division. We recognise the following types of composition:
- the S- or Z-bend composition
- the circle or closed composition
- the grid composition
- the cross-shaped composition
- the diagonal composition
- the triangle or several triangles
- the L-shaped composition
- the composition in several layers
- the symmetrical composition.

■ A, B and C Compositions

Figure A shows different types of composition. Figure B is an example of a grid composition in combination with a cross-construction. Figure C is a simple composition in several layers.

A

C

New ways of plane division

The abstract school has also sought new ways of plane division. It is a challenge to experiment now and then with alternative models of composition and plane division.

The models show where you have your action taking place and where the still space or remaining spaces can be. The active part may consist of the subject or theme, and the passive part may then be the background or surrounding area. From an abstract point of view, the contrast in colour, shape, size or texture is already enough to produce active and passive divisions.

The models vary from full-image plane divisions with a great deal of action and not much calm, to those with little action and a lot of 'empty' space. What is important is that you keep on seeing the painting as a whole. Therefore there must always be a certain amount of contact between the active and the passive parts. Moreover, it is not intended that nothing should happen in the passive parts. The passive parts are simply 'still' in relation to the greater action elsewhere. Investigation of alternative plane divisions increases our options.

Study tip

- Start experimenting with the plane division models shown on the right.
 1. Action high up horizontally in the picture with a large space remaining at the bottom.
 2. Action low down horizontally in the picture with a large space remaining above.
 3. Action vertically starting from the centre with one large and one small space remaining at the sides.
 4. Action diagonally starting from the centre with one large and one small space remaining in the opposite corners.
 5. Action in a horizontal and vertical balance starting from the centre with spaces remaining around it.
 6. Accent on an active part that fills the picture, almost without remaining spaces.
 7. Accent on active parts at the top and the bottom, with a passive part in between.
 8. Accent on several active diagonal parts alternating with passive parts.
 9. Action diagonally starting from one corner with remaining space starting from the other corner.
 10. Action starting from the centre with a lot of free space around it.

■ Examples of plane divisions
The active part has been filled in and the passive part is blank.

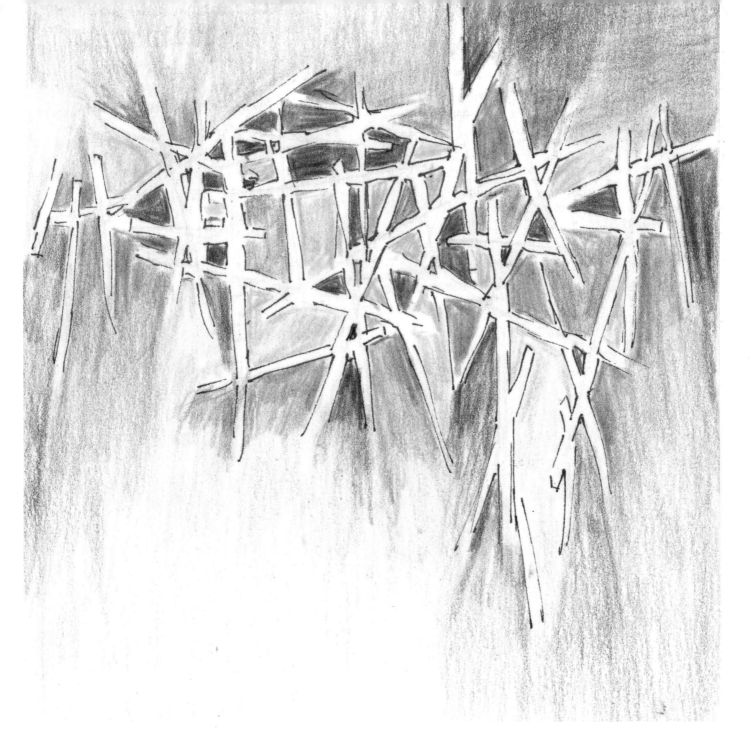

■ Playing with line and plane division

A plane division has been made with the element 'line', with clear active and passive parts. It is a pencil study in neutral soft tone intensity. The active part has been placed horizontally and is compensated above and below by still, calm parts. Executing a vertical 'line' in the still parts now and then gives it connection and cohesion.

Foreground and background

On our picture plane, foreground and background are one entity.
This disguises a frequently occurring problem: we usually concentrate fully on our subject and do not stop to consider that a painting can consist of more. Because our theme is reproduced on a flat surface, this means that even the remaining shape has a valuable function in the whole. How often do we make a painting without thinking about the background in advance, and ruin everything when painting it? Sometimes we even miss out the background, because we simply do not know what we should do with it.

We must be aware of the fact that there is no split between foreground and background in a painting. A painting is an entity in which all the components have an equal function. If we use closed shapes that do not touch the edge of our picture plane anywhere, this accentuates the effect of foreground and background. If we use open shapes, pointing towards the edges of our picture, there is then a connection between foreground and background. If our shapes touch or go beyond the edge of the picture, foreground and background are of equal value and cannot be differentiated or specified separately from one another. If you decide to follow the abstract school, the problem will occur less because in abstract work you are more focused on the total picture plane. Moreover, if you construct your work in several layers, the background is already immediately absorbed into the overall painting process.

Study tip

- It is easy to design foreground and background play for yourself. Start with a number of studies in which you first work on the background and specify your main theme only as the second idea. It takes some getting used to, but focusing on the background is the only way to master it.

■ Study in chalk and watercolour paint

Here we can see a plane division in a reversed L-formation, with an open space remaining at the bottom right. The difference in colour between the main shape and the surrounding area intensifies the effect of foreground and background. Shapes that go beyond the edges of the picture plane reduce that effect.

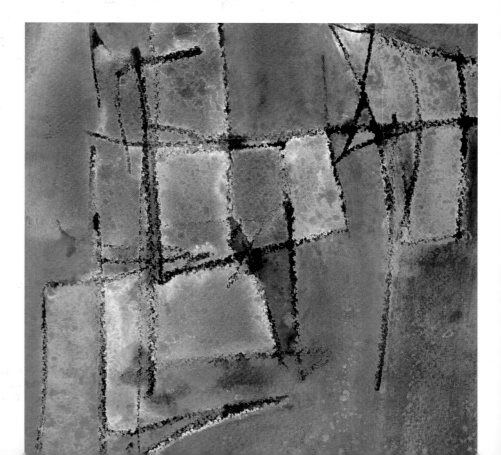

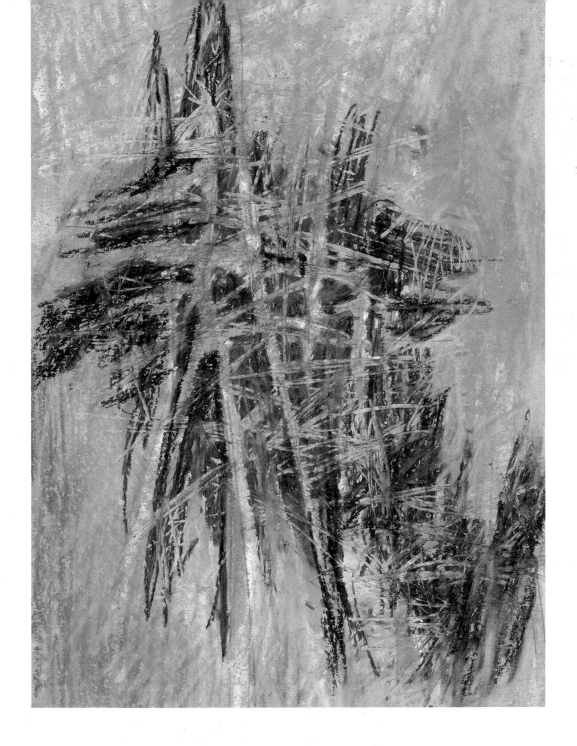

■ Playing with plane division and composition

A study in dark tone intensity on coloured paper with wax crayon. Here the active part is indicated by scratching in the layer of wax. This gives the dark central part extra texture and it becomes more active in comparison with the surrounding area. The active part now runs diagonally from bottom right to top left, leaving the two opposite corners open as a point of calm.

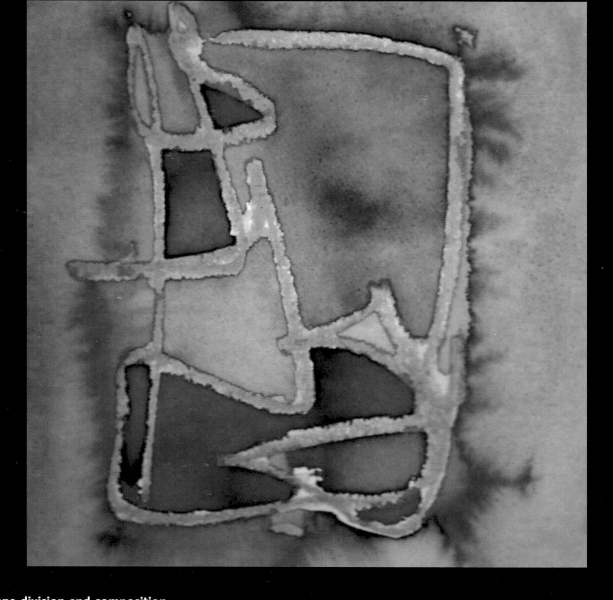

Playing with plane division and composition
This is a composition with closed shapes with open space around them. This gives the impression of a foreground and a background, or surrounding area or remaining space. In this case, it is further levelled out by using the same colours in and around the shape.

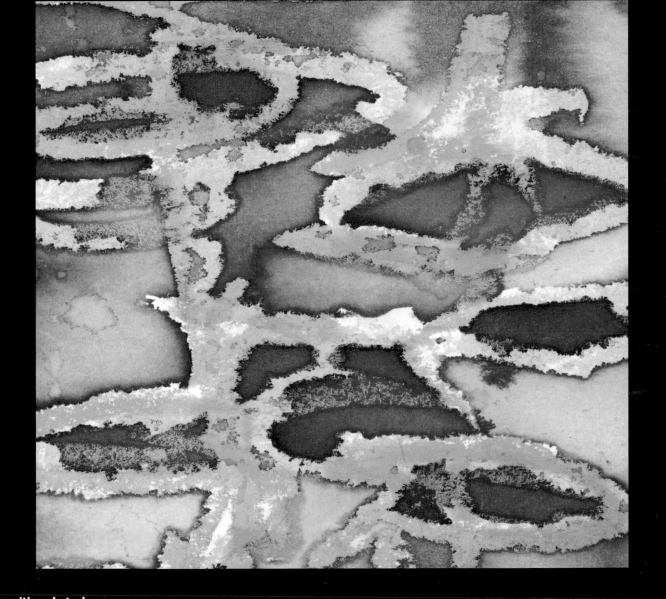

■ Compositional study

This is a full-image composition. That means that there is little remaining space and less surrounding area. These are organic shapes, shown in close-up. By keeping the colour in and around the shapes the same, we eliminate any suggestion of depth. Our theme thus becomes even more strongly abstract.

12. **Technique**

We now know what our pictorial language consists of and how we can use it to construct a composition.

As soon as we start work, of course, we have to deal with materials and technique. The technical options are infinitely large, especially for abstract painters, and it would take an entire book to describe and show all the techniques. So I will confine myself to stating a number of techniques that you can easily experiment with for yourself.

Because abstract painting goes very well with a modern material such as acrylic paint, I will take this as my starting point for summing up technique. You can, of course, if you like, execute the techniques with other kinds of paint, too. If you need further technical information you can consult existing literature.

Acrylic paint

Acrylic paint is a modern material that fits in perfectly with the present age. Powerful in colour, quick to work with, it can be directly placed on practically any ground, be combined or painted over, it is long-lasting, and is virtually indestructible.

Acrylic paint is watertight when dry and cannot be dissolved again, since acrylic hardens like a layer of plastic. Acrylic can be thinned with water and used in either liquid or paste form. The paint therefore lends itself to virtually all painting techniques. The adhesive strength of acrylic is also such that the paint can easily act as glue and can hold both light and heavier materials. The fact that it dries quickly and hard makes direct overpainting possible and encourages layered works. The still damp paint is a good basis for applying textures.

Acrylic paint lends itself very well to the use of other application techniques with which we can artistically intensify our work. Basically, it is a paint with a thousand and one possibilities. We can group the acrylic techniques on the basis of the properties of the material.

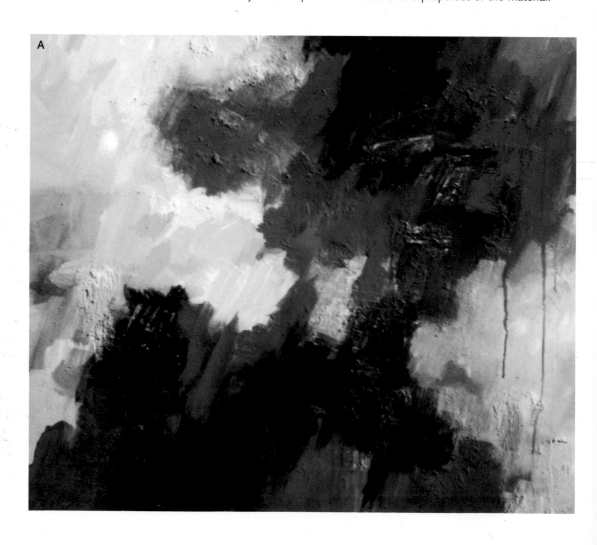

A

Flow techniques

Because we thin acrylic with water we can use the watercolour techniques of wet-on-wet and wet-on-dry, the washing technique and the glazing technique. We also need liquid paint for the drip, blow, spatter, spray and rocking techniques. Aqueous acrylic gives us the effect of colours flowing together with soft contours and random mixes. Here are a few experiments to try.

Study tip

- Thin your paint with water until it is liquid. Make your paper damp, and with large strokes paint blotches with colours running into one another.
- Repeat the exercise on a dry ground, with slightly less aqueous paint.
- Let the work dry, and glaze everything with a warm or cool colour to give it unity and atmosphere. Depending on the kind of pigment and the extent of thinning, acrylic paint becomes transparent and is therefore extremely suitable for the glazing technique. Keep in mind that opaque colours are less suitable for this. It usually says on the pot or tube whether the paint is transparent or opaque.
- Pour your liquid paint directly on to the paper. You can guide the droplet by moving the paper to and fro (rocking technique). Let it dry and do the same again with a different colour. Blow the wet paint in various directions and add spatters and drips to it.
- Use these techniques as the basis for painting splashing waves, for example, or take your inspiration from painters such as Jackson Pollock and Sam Francis, and paint just with spatters and drips.

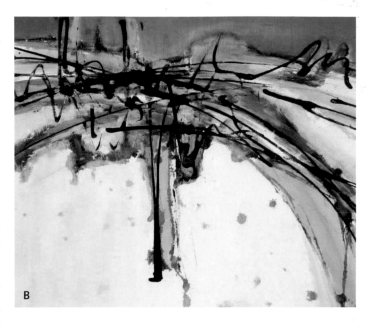

B

■ B and C Material studies
Figure B is a combination of thin aqueous acrylic paint and Indian ink. In Figure C, the acrylic paint was greatly thinned with water and it was possible to use the wet-on-wet technique.

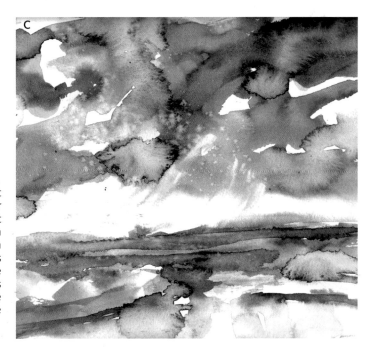

C

■ A Acrylic on canvas 100 × 100cm (39¼ × 39¼in)
Because with spontaneous and expressive painting you do not usually wait until the paint is dry, you arrive at spontaneous colour mixes. However, if you do not keep sufficient control of this, it might just become a mess. It is therefore sensible to practise now and then keeping to bright colour planes. To achieve this, I always begin with the lightest colour, as here with yellow. After that I applied blue fields without touching the yellow. Finally I brought the yellow and blue areas together with the brush in order, in as controlled a way as possible, to mix the colours to make green. The 'accident' with the blue drips worked out well, and taught me something about a more fluid application of the material.

Application techniques

Because acrylic paint has the thickness and stiffness of toothpaste, it is comparable to oil paint. It therefore lends itself to oil paint and impasto techniques: the knife technique, the direct alla prima technique, the structural technique of layer over layer, from thin to thick, from dark to light or vice versa. Moreover, paint with the consistency of paste encourages us to use other application tools: as well as the brush or palette knife, we can work with sponge, cloth, roller, spatula or cardboard.

Study tip

- Particularly practise your brush technique. Try to paint consciously in different directions. Work with a thin, thick or broad brush. Tamp or stamp with your brush, scratch into the paint with the back of it. Make rotating, pushing or scratching movements. The more you vary the brushstrokes, the more vital your work will become.
- Work like Piet Mondrian and paint even, smooth colour planes delineated by contours.
- Experiment with the paint straight from the pot – do not use any water. Put the paint straight on to the canvas or paper alla prima. The colours will continue to mix spontaneously whenever they touch one another until the paint has dried.
- Make a draft sketch on your paper and squeeze a few daubs of paint on to the paper, straight from the tube. Then steer the paint in the desired direction with a painter's knife. Maybe add paint or else scrape the paint off again. Vary the knife texture with the brush technique.
- With a roller, paint a composition with horizontal and vertical stripes, and after it has dried follow up with a second or third layer. The roller gives an angular shaped construction and a fairly even texture. Perhaps vary the rolled areas by stamping them with a sponge or other printing material.

■ Application technique

You can spray your paint directly on to the paper or canvas and then spread the paint with a brush or knife. This will result in a quick underpainting with spontaneous colour divisions, over which you can further elaborate your work.

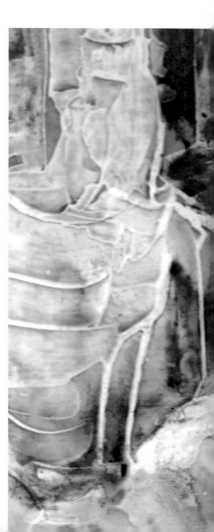

■ Structural study

If we want to give texture to our work, we can treat the ground with different thickening agents. Here, gel has been applied with a palette knife. After the gel had fully hardened, a wash of transparent acrylic paint was added. The study was intended to examine the effect of a gel ground.

Construction techniques

Because acrylic paint is watertight when dry, the underlying dry layers do not subsequently dissolve. The material can then be painted over. Moreover, because of the thickness of the paint mass, it is possible to paint opaquely. Underlying layers disappear, and any 'mistakes' can easily be eliminated. It makes acrylic paint highly suitable for layer-over-layer painting, to give depth and body to the work. It is a good habit to construct your work in several layers, as is also the case with oil paint. Paintings with sparsely and thinly applied paint often lack solidity and character. They sometimes give the impression that we have got no further than the underpainting.

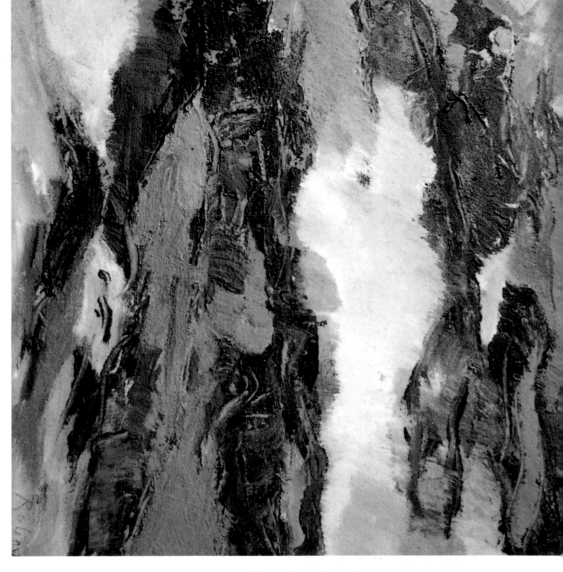

Study tip

• Start with an even underpainting, covering the entire paper with colour. When it is dry, follow up with a simple sketch of your subject and paint the desired colours over this directly and opaquely. Finish off the work with accents and details. If you let the underpainting filter through in places, it intensifies the unity of colour and harmony.

• As with oil paint, you can construct your work from dark to light. You can also, as with watercolour, work from light to dark. Try painting both ways.

■ Acrylic on board

The acrylic paint has been applied here as a thick paste on the ground. The construction of the work consisted of an underpainting in ochre yellow with various blue and green colours over it. Part of the work was lightened with white. The scratches made in the paint while it was still wet allow the colour of the underpainting to filter through in places.

Textural techniques

We can apply texture in the wet paint, on top of the dry paint or underneath the paint on the support material. The thick acrylic mass is highly suitable for this. (See also the section on primary pictorial element of texture, pages 69 to 73.)

Study tip

• Apply a thick layer of paint and, while it is still wet, press rhythmical shapes into it with a seedpod, cork or a small block of wood. Follow up with scratches with a fork or comb, and elaborate the work further by scraping away certain shapes. After it has dried, continue with aqueous paint. The paint then looks for the gaps and leaves textural patterns behind.

• Apply a thick layer of paint to your paper. Draw or scrape the contours of both the main shapes and the details into this layer while it is still wet. Let it all dry thoroughly, and finish the work off with aqueous acrylic. The complete drawing that was already there is now accentuated. Finish it off with colour.

• Paint a ground in two or three colours with rough, pushing brushstrokes, mixing directly on the paper only. Let it dry. Paint stencils cut out of cardboard or use leaves and grasses and press them on to the underpainting.

• We can, of course, also use textural techniques that we know from watercolour, but if we use aqueous acrylic instead we can sprinkle salt on to it, or drip alcohol or water into it, producing textural effects. In this way we can bring alive the effect of rocks, plants or water.

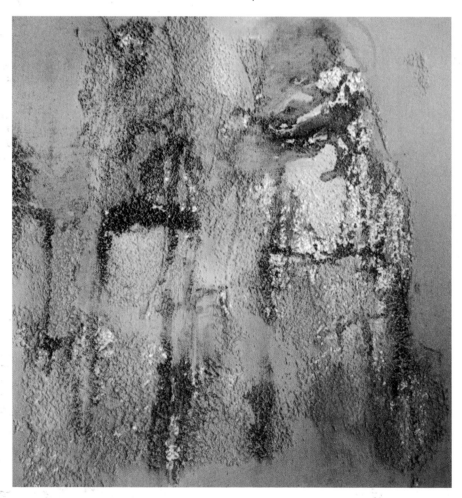

■ **Mixed technique on canvas 40 × 40cm (15¾ × 15¾in)**
An example of building up texture in layers. The basis is a bottom layer of textured paste filled with sand. It was then elaborated in colour. The underlying colours remain visible because the relief-like texture has not been filled with paint.

Filling and sticking

Acrylic paint has great adhesive power and can therefore be applied to virtually any ground. Because the paint dries as a plastic layer, it also holds all kinds of other materials in position and is thus an ideal adhesive. It also lends itself well to the collage technique. We can add fillers to the still wet paint, making it even thicker, so that it stands out on the paper like a relief. Suitable fillers are sand, sawdust, paper, plaster, textured paint, cardboard, rope, wool, textiles, nails, eggshells – anything you can think of. Virtually anything is absorbed without difficulty by the paste-like paint. As well as household, garden and kitchen materials to fill your paint with, you can also experiment with the acrylic media, pastes and gels that are on sale especially for the purpose. In this way we can add texture to both the ground and the painting itself. There are numerous possibilities, all definitely worth the effort of investigating yourself.

Study tip

- Start with a thick, rough underpainting in colour over the entire paper. Sprinkle sand into the layer of paint while it is still wet. Let it dry, and finish the work off with the dry brush technique, brushing lightly over the textured ground so that the paint does not reach the gaps. The ground colour therefore continues to play a role, especially if we use a strongly contrasting colour for the underpainting.
- Stick torn pieces of newspaper on to a sheet of paper. Let it dry. Then make a drawing over the ground, and follow up with aqueous transparent acrylic paint. Make sure the texture of the newsprint remains visible.
- Make a thickened ground with paste or plaster of Paris. Mix the filler into the paint in advance and, using a knife, apply your subject to the ground in rough draft. If you are using a lot of plaster of Paris, use a plastering knife, as it is sturdier than a painter's knife. You will notice that plaster becomes hard very quickly. Finish painting your work in the desired colours. For this technique, you need a hard support material, such as an MDF panel.

■ A and B Textural construction with fillers
We can stick all kinds of materials into the acrylic paint. This means that both thin and thick layers arise, which stand on the ground as a relief, as it were. Once the structure has hardened, you can simply paint over it to finish off the work.

■ C Mixed technique on board 40 × 40cm (15¾ × 15¾in)
First a layer of paste was applied. Then foil was stuck on to it, and contour lines were scratched into the paste. When everything was dry, the work was elaborated in light tones with charcoal and acrylic paint.

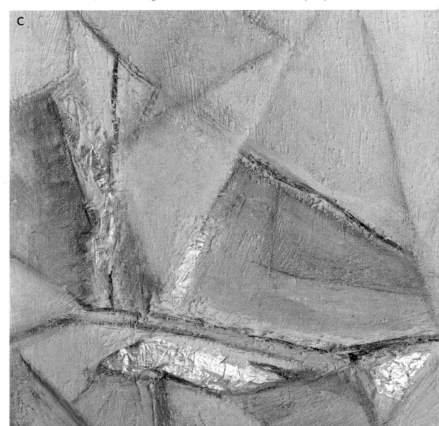

Mixed techniques

Acrylic can be applied in combination with virtually any other painting and drawing materials, including pencil, charcoal, oil pastel, pastel, ink, gouache and watercolour. Look at all the things you have in your cupboard and try them out.

Study tip

- Start with a drawing in ink. Let it dry, and continue painting with acrylic using the aqueous watercolour technique. It can also be done the other way round, starting with an acrylic painting and afterwards applying accents with ink.
- Make a drawing with oil pastel and further glaze the work with acrylic. If we choose to use wax- or oil-containing agents, they will repel the acrylic paint and have the effect of leaving blank spaces.
- Make an acrylic painting according to the traditional oil paint technique, changing to oil paint in the final stage of construction. (Warning: you cannot do this the other way round, i.e. acrylic on oil!)
- Start by painting your paper partly with acrylic paint. Leave bits open here and there. Afterwards, paint over the dried ground with watercolour paint, liquid gouache or coloured ink. These types of paint do not stick well to the plastic-like acrylic, so first seek out the still uncovered pieces of open paper, therefore making it a kind of cut-out technique.

■ **Acrylic on canvas 50 × 50cm (19¾ × 19¾in)**
An example of both mixed and mixing technique. The material is a combination of acrylic and Indian ink. In the first draft the colours were placed side by side and then brushed into each other, meaning that colour mixing took place directly on the canvas. I virtually always mix straight on to the canvas, as this produces many more colour nuances.

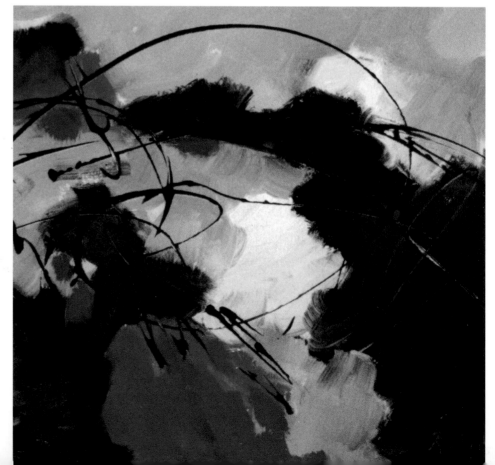

Mixing techniques

In pure form, acrylic has great colour power. Mixing gives rise to an enormous number of colour nuances, and we can even achieve soft pastel-like tints. The more we vary our colours, the more surprising our work. Do make sure you look into the various mixing techniques, since the way we mix our paint has a great effect on the ultimate result. If, for example, we paint with the dry brush technique, broken colours result. If we place colours in small accents next to one another, as in pointillism, or if we glaze our colours over one another, optical colour mixing results. As soon as we brush the colours together, the original colours disappear and together form a new variant. It is advisable in this case to deal with them as expressively as possible and not to mix your colours to death. As well as mixing on the palette with a knife or brush, I would advise you to make sure you have mastered the art of mixing straight on to the paper or canvas.

So far you have been encouraged to experiment with technique, but we have still only touched on a small selection of the many painting techniques. Whatever you do, take time to get to know your materials. Ultimately, you will discover your own way of painting and using the material the way you want to.

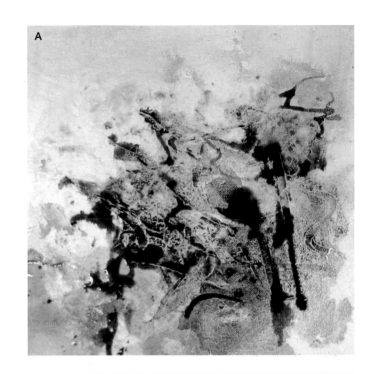

Study tip

- Start with an expressive mixing exercise. Choose your colours and start by applying flecks of the lightest colour. Paint between and over them with the next colour, and let mixing result spontaneously. Follow up with a third colour, and finally use white to lighten the colours already present. Remember, the paint already there must still be wet in order to mix. Finish the work with accents and details.
- Try to create a slow transition between two colours directly on the paper. This requires a certain amount of practice. Start with red on one side and blue or yellow on the other side of your paper and try to let them merge softly with one another via the mixing colour.
- Optical colour mixing requires a special technique. Start your painting with a base colour. Once it has dried, follow up with a second colour using the dry brush technique. With the brush, sweep lightly over the ground, which means that the colour underneath still remains slightly visible (= softening technique).

■ A and B Two examples of mixing technique

Figure A has been constructed with an underlayer of yellow, over which I have worked with liquid paint. The aqueous paint seeks its own path and mixes spontaneously with the other colours. Figure B is a detail from a painting with direct mixing on the canvas. The colour had previously been made thicker with textured paste.

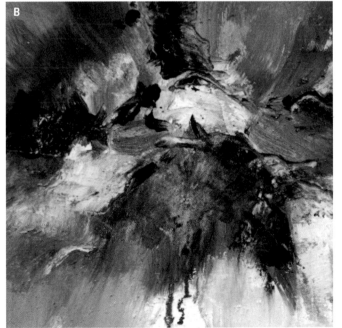

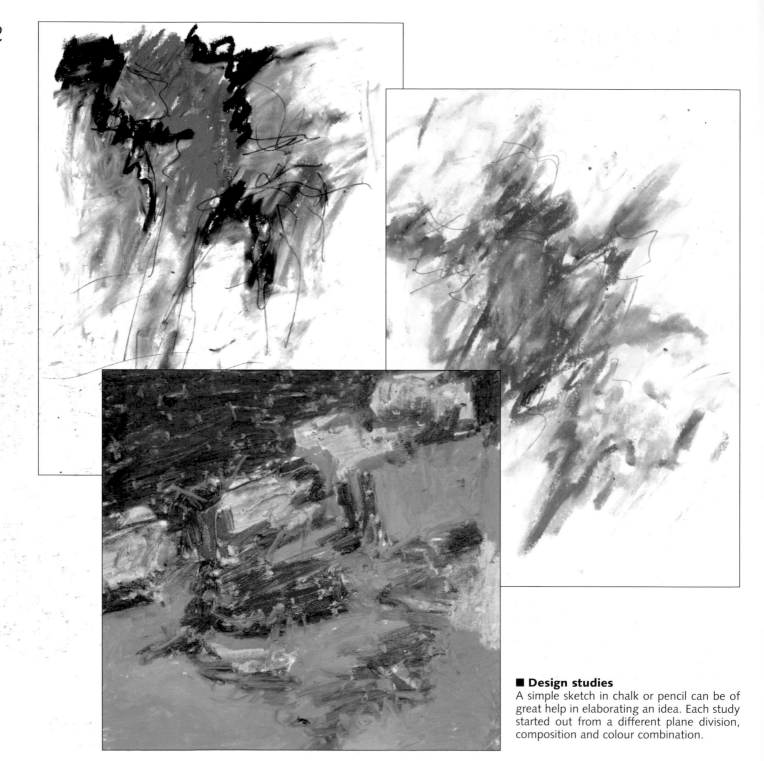

■ Design studies
A simple sketch in chalk or pencil can be of great help in elaborating an idea. Each study started out from a different plane division, composition and colour combination.

13. Looking for inspiration

Source of ideas

We now know all about the pictorial elements, composition, technique and materials, and so we have arrived at the most essential component of painting – the idea, the subject, the theme – because if we have no idea or subject, there is nothing to paint.

At the beginning of this book, we said that you should not sit and wait for assignments from other people, and definitely not look for examples to copy. With originality and involvement in mind, it is very important that you arrive at your own ideas and study tasks independently. You really do not need anyone to get you started. On the basis of your own creativity, you are certainly capable of finding your painting subjects. In addition, it is a very enjoyable and inspiring activity.

The 1001 ideas book

Finding your own ideas is at least as important as developing technical skills. Therefore make your own reference work containing ideas, subjects, exercises and themes. There is a huge number of sources from which you can draw. The most important thing is knowing where to go to look for ideas. As soon as you can introduce some kind of system into this you will be off. Just linking the described abstract pictorial elements to your knowledge of materials, technique, composition and construction gives you a huge arsenal of possibilities. Start by asking yourself questions such as:

– How can I create the pictorial elements of rhythm, pattern or dynamics with line or shape?
– How can I enliven a static, mechanical line?
– In what way can I create texture or make colour contrasts?
– What effect can I achieve with a painter's knife or sponge?

You could write these questions down and use them as the basis to devise your own practice assignments. In this way, fill a notebook with your own ideas. The intention of all this is, I hope, clear. When you are in a painting mood, you only have to look through your book of ideas to get started. If you are stuck and without inspiration, take time to look at your book of ideas and I guarantee that you will always come across something to inspire you. In order to bring some organisation to the many options, you can group your study assignments with the emphasis on the following main themes:

playing with the primary pictorial elements
playing with the secondary pictorial elements
playing with composition and plane division
playing with materials and technique
playing with theme and idea.

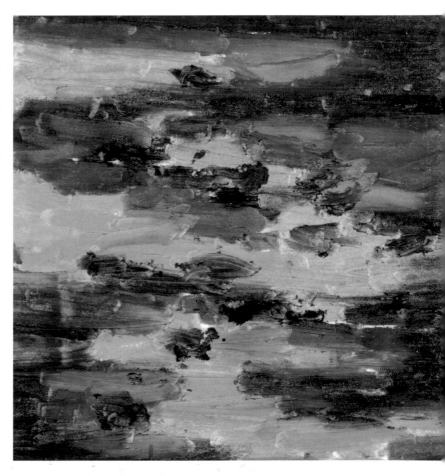

■ Playing with theme and idea
The subject 'water' can be approached from various angles, and is ideal for acting as a study theme. Here the idea was to reproduce the rhythm of ripples on water. The chalk study was designed as full-image.

Your own teacher

Finding your own assignments requires as much creativity from you as making a painting. Once you have realised this, you will discover that you can be your own teacher. The most important thing is that this means you are no longer dependent on others: it is a clear step on the road to freedom, individuality, originality and involvement. Your practice assignments can vary from very simple to complicated. Better ten assignments waiting to be done than just one that you are fed up with right from the start. It does not matter what you put in it, but fill your 1001 ideas book.

Your own documentation centre

OK, a book full of ideas and then what? You must regularly make time actually to carry out your own exercise assignments. Give yourself plenty of opportunity, and do your assignments not once but preferably several times. You will see that they will produce surprising effects every time. Keep your experiments and do not forget to make a note of what you have done and what materials, technique and order of work you have used. In this way, you create your own documentation centre – your very own source of knowledge and technical experience. Have confidence in yourself. Start today on your own documentation centre and fill it with ideas, exercises and the results that have emerged from them. All that remains is the step towards practical application. We are now ready for it.

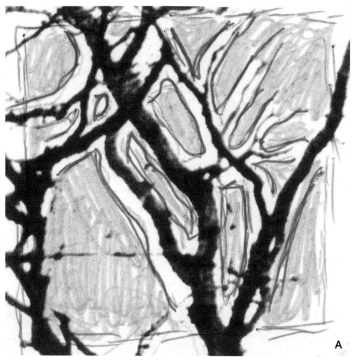

A

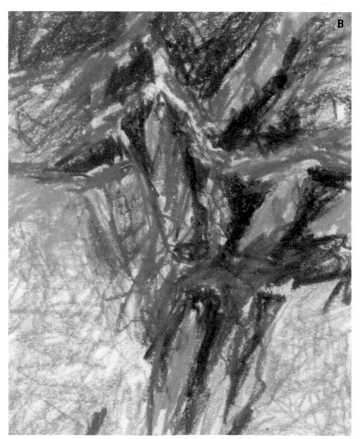

B

■ A, B and C Where do I get shape ideas from?
If you are looking for new shapes and plane divisions, just look at a photograph of a tree. Use the negative shapes of it between the branches as a positive shape for your study. Figure B is a sketch resulting from the photograph of Figure A. Figure C is a further elaboration of it.

Practical application

We are off. What do you have to lose? At most some paper, paint and a few hours of free time. The important thing is what you set yourself as a goal. Is this intended to be a purely recreational pursuit? Do you want to set out to learn particular skills or is the intention to make a representative work? Is the nature of your work intended to be decorative, illustrative or artistic? In other words how do you see your own package of demands? That is completely and utterly dependent on you yourself, your wishes, your skills and your ideals. If you want to add the abstract method to your practical experiences, you must be aware that this is just one study method. The result is then focused on developing skills and not on making art at exhibition level. The method is, on all fronts, the forerunner of play as a learning curve, and so you must regard your own study assignments as such.

A few rules to bear in mind

Before you begin, you need to set yourself a number of rules.
– Have a positive attitude and see each exercise as a challenge. There is absolutely no point in starting on this if you are thinking: I cannot do this, it will not be any good. After all, practice makes perfect.
– It does not have to become anything, it does not have to be anything, it does not have to represent anything, and above all it does not immediately have to be hung on the wall.
– It is no good being economical with paper or paint: it will just restrict your freedom and spontaneity.
– Do not let yourself be distracted, and above all do not immediately ask those at home for a pat on the back. We learn from experience that abstract work in particular does not appeal to everyone. Moreover, we are still practising and we do this firstly for ourselves.
– Make sure you have a pleasant place to work, gather your materials and get started.

What do we want to learn?

– To get away from reality and realise that we can occupy ourselves very happily with paint and colour without a subject in front of us.
– To develop freedom, spontaneity and expressiveness.
– To work from within ourselves and trust instincts and intuition.
– To experiment and make new discoveries ourselves.
– To develop our internal artistic sources of emotion.
– To build up self-confidence.
– To develop pictorial language and our own style.
That is quite a lot. Make sure you have plenty of motivation and effort, then practising becomes simply a game, based on fun and relaxation.

Self-knowledge

Whatever you do, try to avoid immediately thinking about showing your work. It unintentionally puts a certain pressure on your freedom of action and that is just what we want to avoid. If you want to show your work to other people, it is important to know whether you are ready for this, what you expect from it, and what the added value of exhibiting is for you. If you are going to expose your work, the development of the necessary self-knowledge and a healthy critical attitude are at least as important to you as the development of artistic skills. One follows from the other, in fact, because those same skills that enable you to paint, also teach you to look at and examine your work critically. They also form the basis for discovering any shortcomings you may have, and the way to improvement. Try out the following study assignments, and in this way also learn to examine your own work.

Study tip

- Write down the primary elements and look at the illustrations in this book. Try to indicate for each of them which elements are present and on which the most emphasis lies.
- Repeat this with the secondary elements. Try to recognise them and find out the method in which they were implemented.
- Choose an art book and repeat the assignments with the pictorial elements.
- Choose ten abstract illustrations from an art book, and for each illustration examine compositional aspects such as focal point, active and passive parts, plane division and the ratio of foreground to background.
- Take ten different illustrations and try to recognise the form of the composition (see Chapter 11).
- Choose five works from this book or another book as a starting point. For each work chosen you are given the following assignment:
 1. Do the opposite of the picture.
 2. Choose different colours.
 3. Use a different plane division.
 4. Choose a different technique.
 5. Use as many different materials as possible.
 This is a fairly complicated assignment and you will perhaps not always be able to carry it out fully. In each case, choose the maximum possible. It is a tough exercise for which you will need all your knowledge and experience, even just to be able to analyse the example concerned, because that is after all the starting point for your own alternative choice.
- Try to carry out the study assignments given here with your own work. That is what we are ultimately aiming at. This means we are also capable of being our own teacher.

■ Acrylic on canvas 80 × 100cm (31½ × 39¼in)
This is a work that came about quite spontaneously. The dominant warm red, yellow and orange contrast with the black. A very active and dynamic play of lines was applied on top of this. The lines intensify unity and cohesion by linking the different colour fields to one another. An expressive method of this kind is very personal and can be regarded as an individual signature.

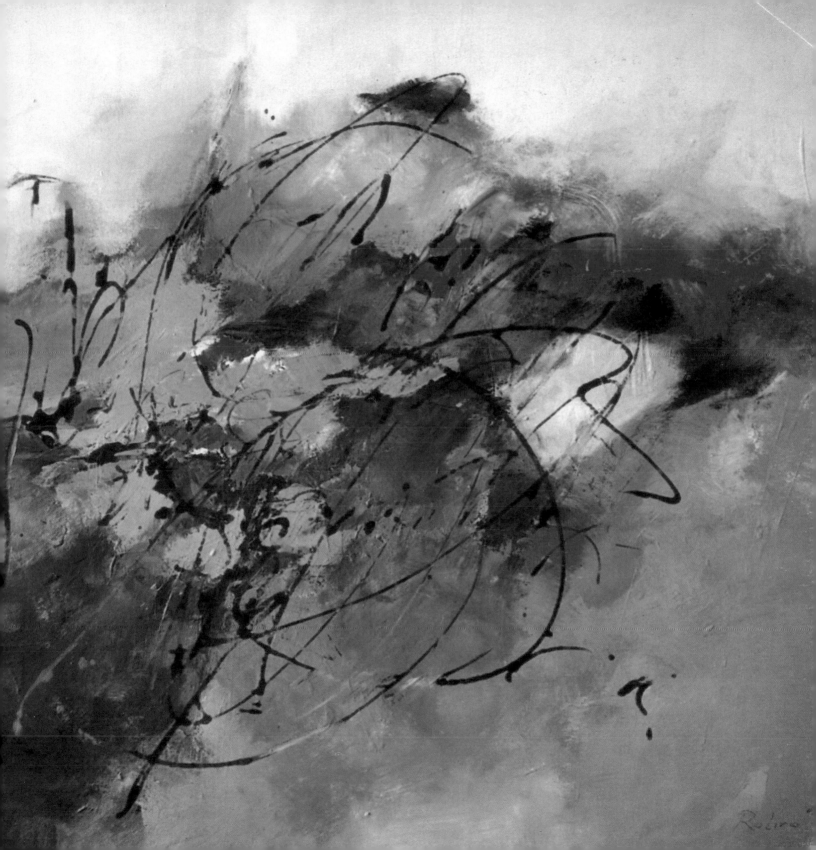

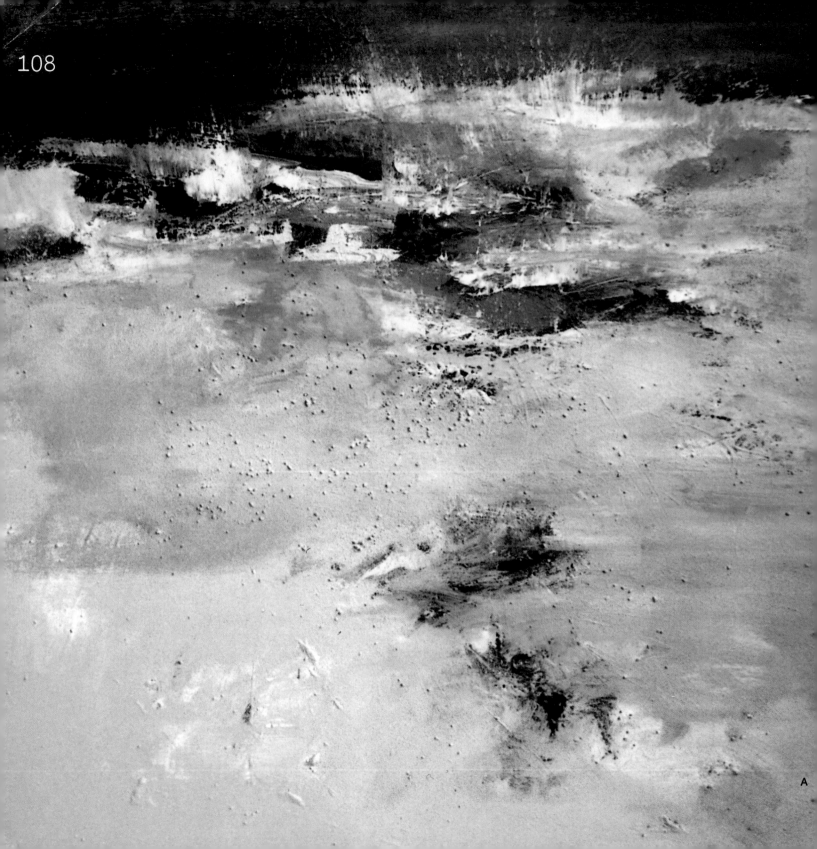

108

A

14. Design strategy

The big work

You now have technical skill and the ability to deal with composition and pictorial elements intuitively and emotionally. By playing, you have carried out your own assignments and developed the necessary personal pictorial language. Now it is time for the big work: elaborating on your own ideas. We gradually want to know whether our practising has had any effect and whether we are now capable of making a full-blown painting. This may vary from a purely decorative work to the reproduction of a particular emotion or aim. In any case make sure that you start from optimum originality and individuality. The important thing is whether you are capable of developing and implementing your own ideas. In other words, you have thought of something and want to paint it.

Internal image–formation

We can set about putting our idea into practice in two totally different ways:

1 Simply start Jump in at the deep end without preparation and just see where we get to. If our work starts from experiment and effect we usually begin in this way. The ultimate result is then completely dependent on the effects that our play with materials and technique produces. There is little support and guidance available and you are completely reliant on your internal artistic intuitive sources.

2 Plan Think ahead about the various possibilities you have for visualising your idea and develop in advance a particular idea, an internal image. On the basis of your internal image, you choose, from your internal resources, intuitively and emotionally, a certain colour, shape, plane division or composition. The internal image guides your painting process and offers something to go by when putting your idea into practice.

If you choose to jump in at the deep end, the strength of your idea and your internal image determine whether you reach the finishing line: a successful artistic work. This works only if your intuitive sources are properly developed and you are capable of anticipating and reacting to what occurs during painting. Do not forget that the painting process essentially consists of solving problems. You have done something, look at it and react to it with the next action: the action–reaction process. If your reaction has the support of an internal image, this can give you direction. If you do not have a clear internal image, you are dependent on your artistic sources. The professional artist has plenty of these, but the artist in training still has to develop this ability. However, there are also many professional artists who work from a design or plan.

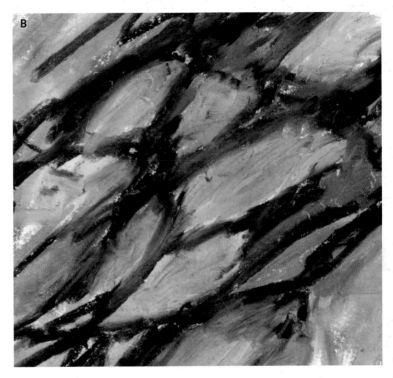

■ B Visualising ideas

This sketch is the opposite of the illustration on page 108. A full image composition, with diagonal dominance and colour planes bordered by thick contours. Quick sketches of this sort help to make particular ideas visual.

■ A Acrylic on canvas 80 × 80cm (31½ × 31½in)

Here the emphasis is on a small active part high up in the picture plane. The still, passive part is quite large and dominant. There is hardly any shape in the painting. Texture and colour nuances provide variation and cohesion. The work began as a completely abstract experiment, but during the painting process became more and more a sea with splashing waves. This way of working from abstract to figurative occurs fairly often.

The concentration stage as the starting point

We should regard the formation of the internal image as a concentration stage that precedes the painting process. It is your mental preparation, in which you form a specific representation of your idea. This representation forms the basis for your act of painting. The preparatory concentration phase is intended only as a starting point. After that, the action–reaction process is again given full freedom. In addition, the concentration stage gives you the chance to tackle any problems in good time. It helps to prevent 'getting stuck' and 'just messing around'. Art is not about strokes of luck, but all about guidance from within our resources based on an internal image. It may seem rather laborious, but it is definitely worth the effort, since:
– the more we are able to structure our idea in advance, the greater the chances of success
– the clearer the internal image, the more strongly the act of painting is guided from inside to outside
– the more we are able to solve questions in advance, the fewer problems there will be later
– the fewer problems there are, the more spontaneous and more expressive our act of painting is.

We can specifically designate the concentration stage as the 'draft' or 'design' strategy.

■ Design sketch with coloured pencil
We generally use a medium such as coloured pencil to show even coloured areas, since that is what we learned in our youth. It is useful to use that same coloured pencil differently for once. This is a study with the emphasis on line, colour and structure. The dominating horizontal lines are placed next to one another rhythmically in different colours. A strong horizontal emphasis almost gives the idea of a landscape, although that is not the intention.

■ Study with coloured pencil

The composition has been structurally conceived. A plane division has been sketched as spontaneously as possible with horizontal and vertical lines. The pictorial elements of balance and variation of size were crucial in this. In principle, all the shapes can be traced to geometric rectangles. They emphasise unity of shape. Suspense and a focal point are created by greatly varying the size of the shapes. The basis of the construction of the composition can be recognised as a cross shape. The way in which the study has been elaborated with coloured pencil gives a very special textured effect. Movement, action and direction are intensified by the diagonal line structure. So even a structural composition can be really dynamic and vital. Moreover, if, as here, we place stripes of different colours next to one another, we are taking advantage of optical colour mixing.

Study tip

- Start off with a box of coloured pencils or, another idea, with pen and ink. Divide a sheet of paper into eight sections and make different shapes and plane divisions using the hatching technique. The hatching technique is based on working with a pen or pencil and therefore being able to give our planes tone and colour with lines alone.
- Try also to effect different tone or colour variations with the dot technique. This involves varying numbers of dots, thick or thin, close together or further apart.

Painting plan

If we take advantage of a concentration phase, we are imperceptibly working on a particular design strategy. In this we take decisions on things such as: what am I going to paint? With what? How? On what? Let us systematically follow the steps that require our attention in a design.

The subject

Are we dealing with reality, or are we choosing total abstraction? Does our subject have a meaningful emotional charge, or is it a question of technical, decorative or artistic expressiveness? We have here a choice of a broad scale of purely abstract shapes and abstracted shapes from reality. So it is not so much a question of the theme itself, but more of the shape of it. So we are not painting the trees or a wood, but are using the whimsicality of the branches as an abstract shape. We are not painting a landscape, but using the contours of ditches, hills or woods as abstract shapes. Develop as much sensitivity as possible for 'seeing' and discovering abstract ideas of shape, then at least you will not be stuck for a subject or theme.

The materials, the technique and the style

Our prime tool is the painting materials. What sort of paint are you going to start with? Will it be a mixed technique? What ground will you choose, paper or canvas? Which technique goes best with your idea? Knowledge and experience are especially indispensable here. Naturally you will also choose the style in which you are going to work: abstract, figurative, realistic, expressionist, structural, improvising, and so on.

Unfortunately, in practice, it often works out that our preparations for painting stop after the subject and materials have been chosen. In the best case, we also think in advance about the technique. However, there is a number of other things that it is also important to plan ahead for, to prevent problems later.

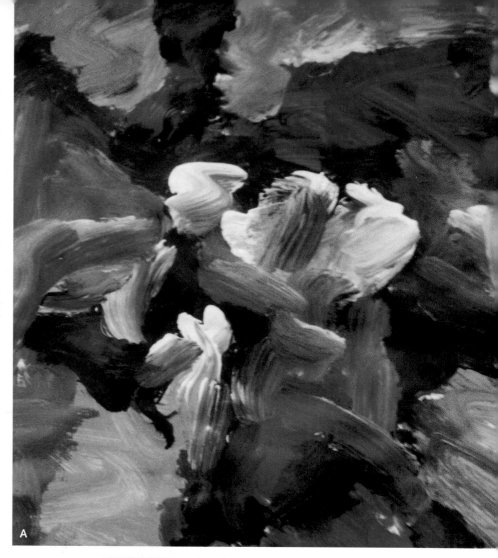

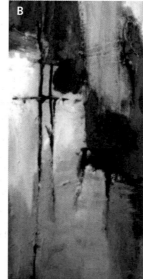

■ A and B Style, picture plane and theme

Style, technique and picture plane play an important part in elaborating our idea. Figure A is a style study in acrylic. The paint has here been applied expressively with contrast and structure. The character of our work is created partly by the way in which we use our materials. Figure B is a style study on a variant picture plane. More rigid and less structured shapes give an image of tranquillity.

The picture plane

A fixed point in our design strategy is the conscious choice of the size of the support material. The picture plane ultimately forms the defined limits of the painting. Is the picture plane large, small, square, rectangular, long, narrow, wide, horizontal or vertical? In fact, the choice of the picture plane will be unconsciously influenced by the subject, the materials, and the technique already chosen. A pen drawing, for instance, requires a smaller plane than an acrylic technique with a large brush. Tall buildings probably require a different size from a polder landscape. But the reverse also occurs. Especially with non-figurative work, the choice of the picture plane may be the inspiration for a particular composition, plane division and shape language. In other words: the choice of the picture plane is an essential and influential part of the design strategy.

Unfortunately, the importance of a well thought out choice of picture plane is too often underestimated or simply overlooked. We then get paintings where the subject simply does not fit in to the picture. We are sometimes left sitting hopelessly with a large empty space. Therefore try to give conscious thought to the size of your picture plane and prevent yourself from choosing standard dimensions more or less out of laziness. Differing picture sizes can produce exciting alternatives.

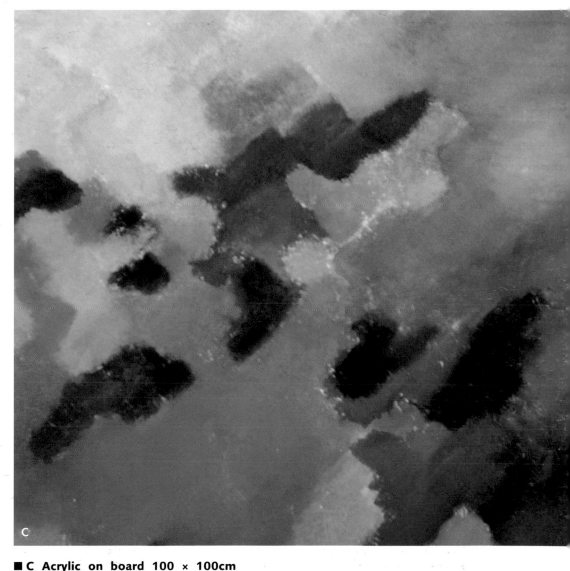

C

Study tip

- Using a theme, make three different preliminary studies, elaborating on one of them. Take as your theme something like traffic, nature, architecture or, more in the emotional sphere, safety, solidarity, etc. Think about the concentration phase beforehand!

■ C Acrylic on board 100 × 100cm (40 × 40in)

An example of a painting inspired by a theme. I wanted to turn the variety and at the same time uniformity of sounds of the subject 'orchestra' into colour. The primary colours represent the main groups of instruments: the string, wind and percussion instruments. The question was: how do I create cohesion and harmony among the quite contrasting colours of red, yellow and blue? Each colour began from a different corner, as in an orchestra the different instruments are also grouped. The fourth corner became the combination of yellow and blue. Orange brought a link between red and yellow. The cohesion was intensified by repeating separate blue, red and orange planes. This also reflected the idea of the sounds of the orchestra flowing together. Yet, because the fairly rigid block-like shapes have been placed on the diagonal, there is still dynamism, an element that in my opinion is integral to music and should therefore not be left out. I deliberately chose a square format in this case, in order to indicate the equality of the colours and therefore the sounds in an orchestra. This work was therefore based on a clear idea and plan.

The plane division and composition

Another important decision relates to the plane division. Even at the first brush or daub there is a certain composition and plane division. Here too, just starting off wildly is asking for trouble. It is better if we have a specific plane division in our heads in advance, and to some extent already know what we are aiming at with the brush. Moreover, we can then consciously stop and think about compositional aspects, such as focal point, foreground and background, active and passive parts. The plane division is the basis of the ultimate composition. Choosing a plane division model in advance reinforces our starting position.

The pictorial elements

The next step in our strategy involves the pictorial elements. What effect do I need and what element should I use for this? They determine whether our painting is 'good' or only fit for the wastepaper basket.

It is useful in your design strategy to look at the primary and secondary elements one by one and make your choice. They also ultimately have an influence on the other components of the strategy. If you want to use texture in your work, for example, you will have to adapt your technique to this. They also influence one another in reverse. For example, how can you produce the chosen subject in a dynamic way? Is there enough variation in the chosen technique and materials? However, many of the pictorial elements come into play only once the painting process begins. Fortunately you cannot and do not need to determine everything in advance. However, there is one important element that you must definitely include in your design strategy, and that is colour.

Colour plan

Colour, especially for abstract work, has a particularly communicative and expressive function. Colour has a strong influence on the picture, and is responsible for the power of attraction emanated by the work. I strongly advise you to include the making of a 'colour plan' in your strategy. What colours are you going to use? How are you going to build up these colours? Possibly do a colour test. What does the colour mix look like? Are the colours powerful enough and sufficiently varied? How do we distribute the colour roughly over the picture plane? I can really recommend making a simple colour sketch in advance. It reinforces your starting out point, and actually gives some insight into colour distribution and harmony.

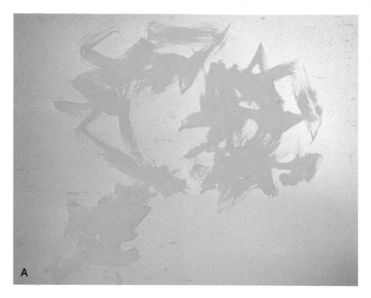

A

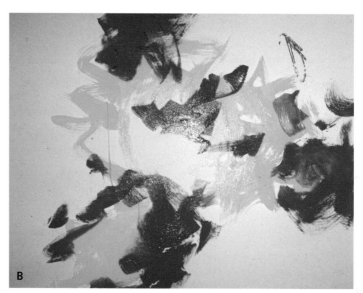

B

■ A, B, C, D and E Building up colour

Figures A to E show the sequence of a colour construction with acrylic paint. If you want to work in an expressive painting style, you will probably use spontaneous colour mixes. To prevent all the brightness disappearing, you can start your work by building up the work colour by colour, as this series of illustrations shows. If, using a simple colour plan, you already have some idea of what colour you want where, your starting position is comparatively problem-free. Figure E is the point at which the first construction phase is finished and the actual painting begins.

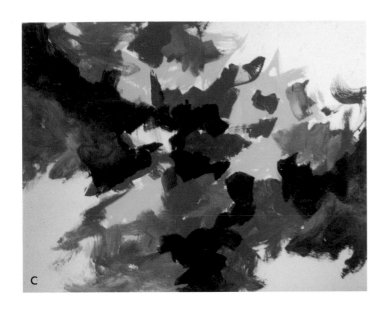

C

D

Study tip

- Make a colour plan based on your own design.
- Now, with the same colours and the same composition, make a different colour distribution.
- Use the same composition again for a colour plan with completely different colours.

E

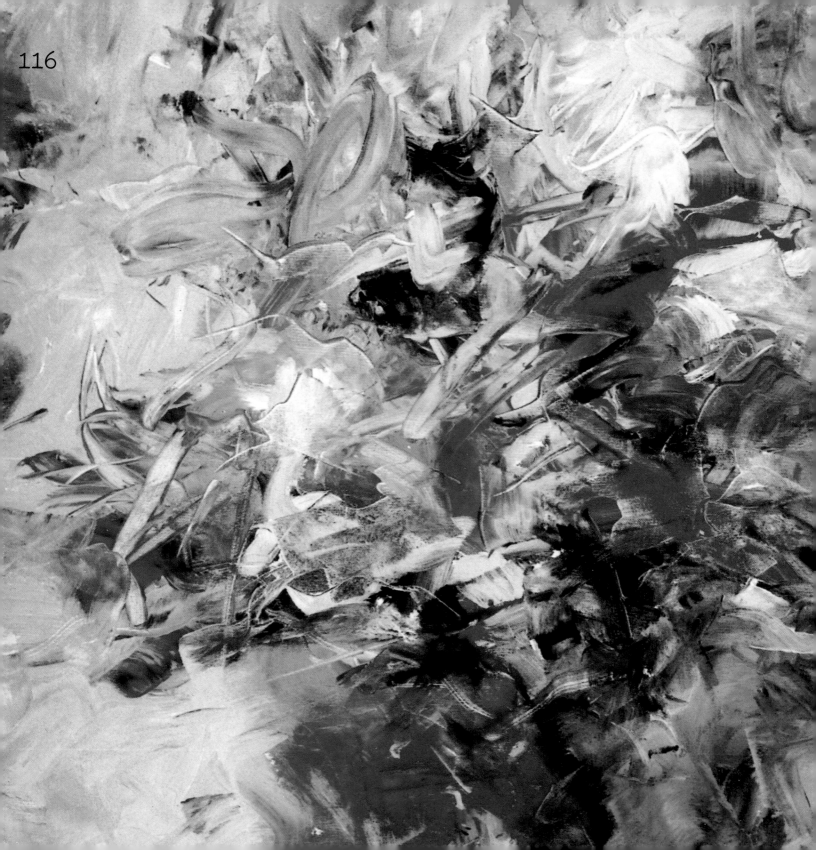

The design

Once you have made a number of choices in your design strategy, it might be sensible to put it down on paper as the design. A design tightens up the internal image and trains the powers of imagination by which our painting process will later be guided. The design, however simple, literally shows whether what you had in mind satisfies the criteria for composition. Does it fit in the image plane? What are you going to do later with the 'empty' space that might or might not be present? Where is your focal point? The result of the design strategy, our design, can be handled in two different ways:

1 as a structural drawing
2 as image building.

1 The design as a structural drawing is an elaborated design and can adopt the form of a preliminary study, in which the majority of the painting problems have already been dealt with. The intention is to use the design later as the model for our painting. The painting process is therefore, of course, far less spontaneous and more tied to the individual assignment. That does not mean that there is no longer any freedom of action. After all, you set your own rules about whether the model should be implemented or whether it can be done differently. The choice is yours. Here, too, I give preference to as much freedom as possible. The structural drawing should also never act as a rigid straightjacket, because then there is no scope for our expressiveness.

2 The design as the creation of an image is at the most a rough sketch. It is often no more than a simple incentive to get started. No visually binding model exists. Yet here too the design stage is indispensable, since it enables us to intensify the internal image to such an extent that it gives us enough support to guide our actions. By this route, expressiveness is given a great deal of scope and it is possible to anticipate and react without limit to everything our painting process produces in the way of surprises and coincidences.

The design strategy as a whole is not intended as an inflexible step-by-step plan. The plan makes it clear to us which facets have an influence on the result. The extent to which we use the design strategy varies from individual to individual. It also depends on talent, experience and the subject on which our plan is based. One person likes working from a structured design. Another prefers a simple sketch or a vague internal image. That does not detract from the fact that we need that thinking phase in every case. So take time to concentrate on the different steps of the design strategy:

– **the design**
– **the materials, technique and style**
– **the picture plane**
– **the plane division and composition**
– **the pictorial elements**
– **the colour plan**
– **the design.**

■ **Acrylic on canvas 80 × 80cm (31½ × 31½in)**
Sometimes we are just not in the mood for a calmly thought out structured composition or design. Nevertheless, it is recommended that you concentrate sufficiently on what you want before you start painting. This time, I was less successful in this. I was too impatient. I set out completely unprepared. So the result is just what you would expect: a mess. Yet you could say that this work reflects perfectly my state of mind at the time – worked up and rather disorientated. Almost the entire painting consists of restless structures. There is no delineation, clarity or calm anywhere. What is there has simply emerged, a kind of outburst or escape. It is good to encounter yourself like this once in a while, and at any rate it confirms that emotion plays an immensely important role if you succumb to it.

Design technique

In this context, I would like to focus attention on two techniques that are very useful for practising composition and design.

First is the collage technique, which enables us to practise extensively and develop our feeling for composition and design compactly and directly. At a glance, it gives an overview of plane division, variation in shape, colour, texture, and the other pictorial aspects. It helps us to visualise a picture plan quickly, and to get started on the basis of this. We can use torn newspapers or coloured paper as collage material. It is not actually necessary to stick everything on. Sliding and placing free shapes is quite enough to give an image of plane division and colour harmony.

Second, if we have access to a computer with a drawing program, we can follow our instincts and practise endlessly playing with line, shape, colour and composition.

These two possibilities, which in themselves are already a source of inspiration, function particularly well for the development of artistic skills and visualising ideas and internal images.

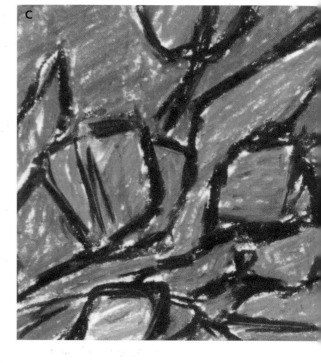

■ A, B, C and D Design technique

Figures A and B are design games using the computer. Figure C is an elaborated design in oil pastel that can serve as the basis for a painting: the structural drawing. Figure D is a design with collage technique. A quick and conveniently arranged way of reinforcing the creation of an internal image.

15. Conclusion

Freedom and restraint

So if we look at the entire sphere of activity of the abstract method we can ascertain the following: on the one hand total freedom is encouraged to awaken the internal sources and to warm them up for the big work; on the other, planned action is recommended in order to apply system to the many painterly facets so as not to lose one's way. The sphere of activity of the abstract method, as reproduced in the diagram below, can be seen as a double unit in which freedom and restraint form a balanced whole.

The plan	The game
Preparation/concentration phase	Practice/experience
The painting plan	**Free play with**
Design strategy	Pictorial elements
Design	Composition
In advance	During
Conscious	Unconscious
• The subject	Spontaneous
• The materials, technique, style	Emotional
• The picture plane	Intuitive
• The plane division, composition ⟶	
• The pictorial elements ⟵	
• The colour plan	GOAL
• The design	Development of internal artistic resources: feeling for colour, shape, composition, harmony, unity, etc.
GOAL	Intensification of:
Intensification of:	Acting intuitively
Internal image	Action–reaction process
Power of imagination	Trusting one's own intuition
Development of idea formation	

The painting process:
technical, painterly, artistic and
expressive skills

The result:
creative, expressive,
original and individual

Play and plan as a double unit

Working according to a painting plan seems to be the direct opposite of the free, spontaneous play that is the main theme of this book. But there is another way of looking at it: after all, we are talking here about two totally different study situations, each with its own goal. Discovering and developing your own way of expression through play is one side of the coin; finding and putting into practice your own ideas is the other side. Both require their own specific approach. The aim of play is to activate and develop our internal artistic sources on the basis of spontaneity. The aim of the plan, on the other hand, is to organise the details given to you by your internal resources.

In other words, play teaches you to develop your feeling for colour, shape or composition. The plan teaches you to consult those resources systematically, and in doing so you follow a path that brings order in the multiplicity of paths at a moment when there is still time for it. Afterwards, when you start on the actual painting, the results of your play and plan come together. Play and plan therefore form the double unit that serves as the starting point for every act of painting. One time your action will emerge more from play, another time from the plan. Your experience, talent and artistry will together be responsible for the starting point you choose and the result produced by it.

The painting process

Once we have given our painting idea mental shape, we can really begin. If we study via the abstract method and give play full scope in this, we develop all the other painting skills too. Each painting process, however simple, increases our knowledge and experience in respect of technique, theme, materials, artistry or skill of expression. The painting process varies, depending on the task we set ourselves, from emotional, spontaneous, dynamic and expressive, to well thought out, directed and controlled.

It is obvious that we should give the painting process itself as much scope as possible, which means that we allow ourselves to let the process take its own course, irrespective of the amount of planning and preparation.

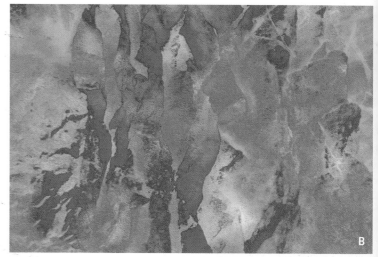

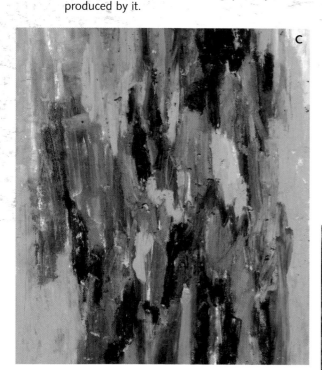

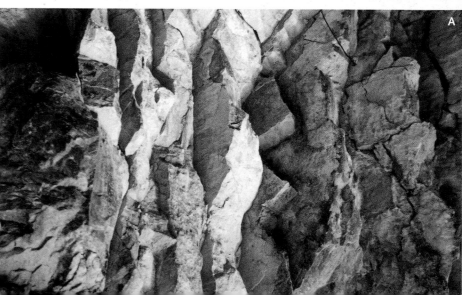

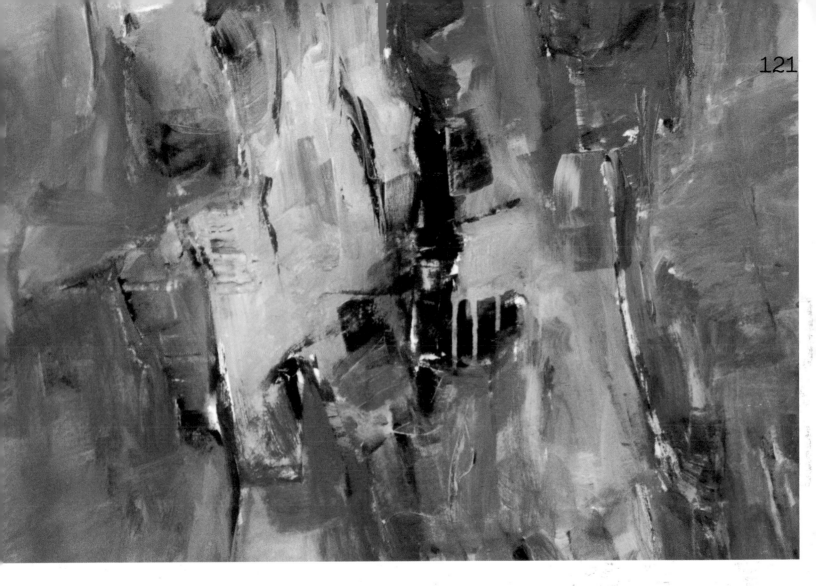

■ A, B, C and D From plan to play

This is a form of development from concrete to abstract and from plan and design to play.

Figure A is a photograph of a section of rock that I used as the basis for a design with the computer. You can see the result in Figure B. This design, in which the concrete shapes can now be seen only as an abstract play of colour, became the starting point for the study in pastel in Figure C.

■ D Acrylic on canvas

I began the painting with the computer design in Figure B and the sketch in Figure C in mind. I had taken a fairly large canvas, and quite soon the painting process went in a completely different direction. I just let it happen and carried on intuitively and emotionally. The photograph was taken half way through. Later it was changed so much that it would now be impossible to recognise it.

The result

A successful work comprises two sides: successful for the artist and/or successful for the observer. For the artist, something can be considered a success if it satisfies the expectations and the demands made of it. If this is the making of a study, it only requires us to finish the assignment and for the result to give us a pleasurable and good feeling for the work to be a success. If we want to make something at a decorative level, our demands are slightly greater. If our goal is to make an artistic work for an exhibition, there is even more to take into consideration.

The important thing is that we do not set our own expectations and demands too high or too low, but base them on a healthy measure of self-knowledge: what can I do, what do I have in me? Get to know your own talent, skills and level. Using this, determine your goal. So, here, too, turn back to yourself and make a reasonable assessment of your capabilities: overestimation and overly high expectations lead to disappointment and giving up; underestimation means there is insufficient stimulus and leads to petering out. Here, too, seek a balance between ability and desire.

Good work

If at all possible, we naturally hope that we can do good work. But what is good? When can we say that a work has been successful? That sounds as if it is enough for the work to satisfy certain conditions or rules. If it were that simple, we could just apply those rules. I think it is clear that a successful work is not a sum of conditions, requirements and external features. In fact, it is far more complex and more involved with internal emotional processes. We can say that a work has a chance of success if, from a technical point of view, it emanates an impression of expertise and experience and radiates such a power of attraction that we cannot get it out of our minds; basically, a work that has communicative characteristics and, as it were, invites us to a visual conversation.

The only really clear demands we can make of our work are the conditions that are at the centre of this book: a work must develop from technical, painterly, artistic and expressive skill and be based on creativity, expressiveness, originality and individuality. This makes it a reflection of ourselves, of our inner being, our nature, mood, feelings and commitment.

■ **Acrylic on canvas 80 × 100cm (31½ × 39¼in), detail**
If our work really has arisen from within ourselves, originally and individually, you can, in that sense, call it a success. The question then is whether it is necessary to measure success against the outside world. In other words, do we paint for ourselves or to please others? Does our feeling of satisfaction lie in our own realm of appreciation, or do we need others for this? The answer to this is self-evident: in fact, enjoying painting has more to do with the painting process itself than with the result, so let us concentrate on that.

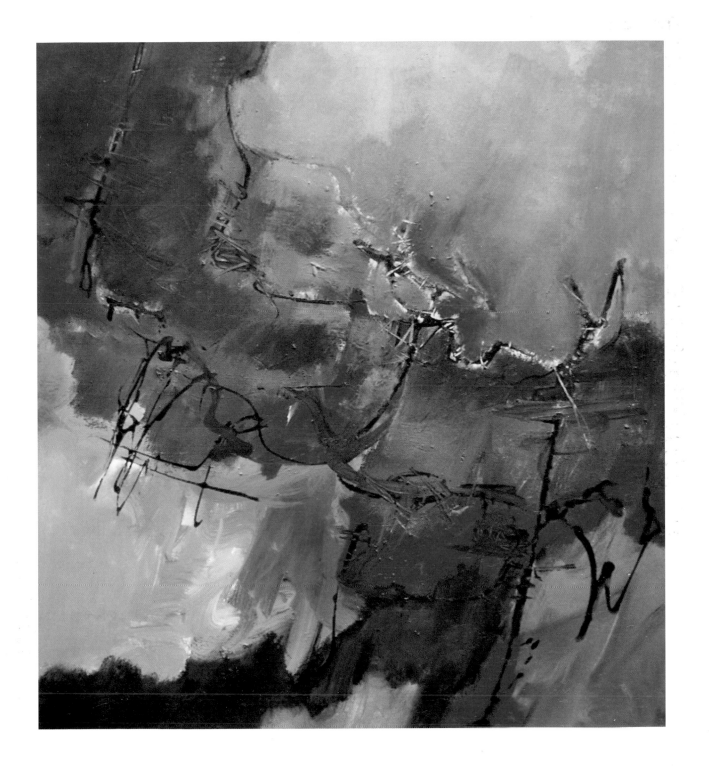

It works

All in all, there are plenty of reasons to justify the choice of a painting method originating from abstraction. The abstract method should, however, be seen as a supplement to existing methods. The method is not intended for making exclusively non-figurative work, but in fact for developing basic conditions that are of value to every painter irrespective of level or style. On many fronts, it has since become evident that the method works. The reactions of amateur and professional painters and of teachers and students make it clear that the method can stir up many things and offers new opportunities. The method has, in some way or another, an influence on freer and more expressive painting, and helps those who are stuck to get going again. Furthermore, it puts originality and the development of one's own pictorial language into the foreground in such a way that we become aware of the necessity of taking personal control.

One more thing in conclusion

I wanted to show you the road to an alternative, challenging way of painting, a road on which your talent is given maximum freedom. I have deliberately not taken you by the hand, for you must map out your own route. Your own initiative, efforts and motivation are indispensable for this, relaxation and pleasure are your reward. Whatever you do, try to fathom the essence of creativity, expressiveness and, above all, originality and individuality, and discover what painting can mean to you.

I wish you much success – and enjoy it!

Rolina van Vliet

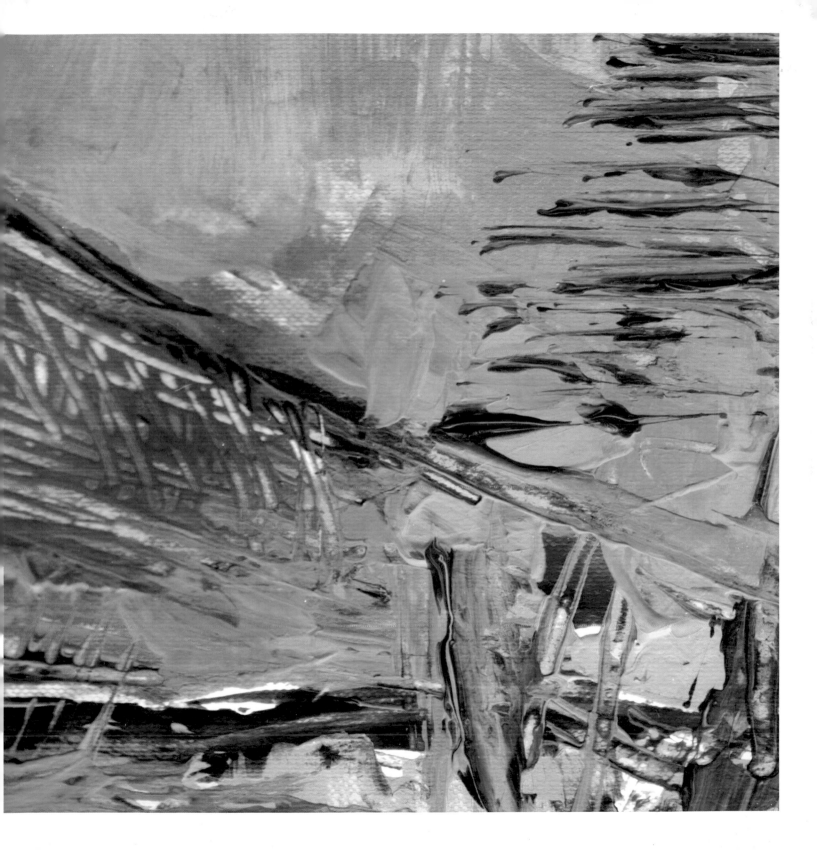

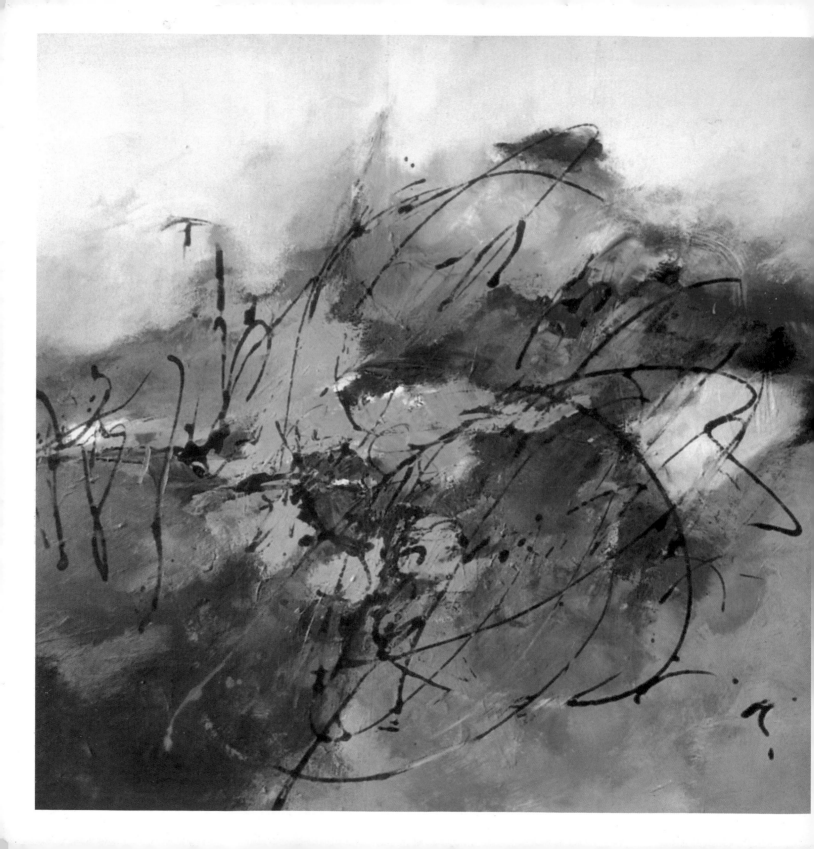

First published in Great Britain 2009 by Search Press Limited,
Wellwood, North Farm Road, Tunbridge Wells, Kent TN2 3DR

Reprinted 2010

Originally published in Holland as Ga Abstract by Arti, Alkmaar

Copyright © Rolina van Vliet

The Publishers acknowledge that 'Rolina van Vliet' asserts the moral rights to be
identified as the Author of this Work.

English translation by Cicero Translations Ltd

English edition edited and typeset by GreenGate Publishing Services, Tonbridge

ISBN: 978-1-84448-427-0

Printed in China